# KAFUKU'S GHOST

AN EXAMINATION OF "DRIVE MY CAR"

MOVIES SCENE BY SCENE
BOOK 2

DAN CONLEY

Copyright © 2026 by Dan Conley

All rights reserved.

No part of this book may be reproduced in any form or by any electronic or mechanical means, including information storage and retrieval systems, without written permission from the author, except for the use of brief quotations in a book review.

❦ Formatted with Vellum

When real life is wanting one must create an illusion. It is better than nothing.

— ANTON CHEKHOV

# INTRODUCTION: HAMAGUCHI, MURAKAMI AND CHEKHOV

While working through "Drive My Car," I read for the first time Haruki Murakami's "The Wind-Up Bird Chronicle," widely considered his masterpiece.

While nothing would be more Murakami-appropriate than going on a long tangent about that novel, I'm going to add just a few observations about similarities between the works.

While working through "Drive My Car," I read for the first time Haruki Murakami's "The Wind-Up Bird Chronicle," widely considered his best work.

While nothing would be more Murakami-appropriate than going on a long tangent about that novel, I'm going to add just a few observations about similarities between the works.

I had a sense from my first couple of views of the film that it was just as much an adaptation of Chekhov as Murakami, and I feel even stronger about this after diving deeper into the Japanese novelist's work. There are, however, some interesting parallels between "Drive My Car"

and "The Wind-Up Bird Chronicle," specifically around the twin obsessions of the protagonist: trying to understand a lost love and diving deeply into projects as a way of diverting the mind from that task.

And this is, perhaps, a difference between Chekhov and Murakami. Chekhov's women are psychologically complex but knowable. There are deep reservoirs of thought and feeling behind Chekhov's women, but their actions and words cohere, many times more so than those of the male characters.

Murakami's women are impossible to figure out. Yes, there's a backstory that helps illuminate their mystery, but ultimately that backstory does nothing to help unravel the knots; it just helps you understand why there is a knot. So Murakami's women are often acting strangely, and they won't tell you why; they'll just add story upon story to the mix so you can empathize with their complexity, but still never get a handle on it.

So while I think "Drive My Car" is a much more humanistic piece than what you'd expect from a Murakami adaptation — which is Chekhov's influence — the ghostly woman at the core of the story remains firmly in the Murakami universe. There are other women in the film, however, who aren't as mysterious, and over time we will get to know them. And perhaps this is the point of the film — that life is full of complicated characters that don't all have to remain mysteries to us. It is possible to get to know some people well.

We just have to learn when to let go of the ones who stubbornly refuse to let us in, especially if they are no longer alive to clear up the mysteries.

While "Drive My Car" is officially an adaptation of Haruki Murakami's short story of the same name, which

appears in the short story collection MEN WITHOUT WOMEN, Ryusuke Hamaguchi's Cannes festival-winning screenplay is far more complex.

Besides other Murakami stories, Hamaguchi draws from Anton Chekhov's play "Uncle Vanya" for much of his story's material. We hear pieces of the play throughout "Drive My Car." The film's protagonist, Yūsuke Kafuku, is obsessed with the text and mentions its unique power often in the film.

But for much of the film, Kafuku evades an important aspect of Chekhov's masterpiece — the play's powerful, nearly religious, catharsis.

At his darkest moment, Kafuku grasp onto a paraphrase of Sonya's lovely monologue that closes the play. It has become his sacred text. It offers grace, but also gives Kafuku the answer he needs most: he can't turn away from playing the lead role of Vanya again; it still has something left to teach him.

A.O. Scott of the New York Times said it well, that both "Drive My Car" and "Uncle Vanya" end:

> with a middle-aged man and a younger woman coming to realize that they are bound by a love that isn't romantic or sexual, but in some way spiritual.

# 1

# HAMAGUCHI'S GHOST STORY

Haruki Murakami begins his short story "Drive My Car" with a lengthy narrator's note about his protagonist Yūsuke Kafuku (who I will refer to throughout the book as Kafuku) and his negative attitude towards women drivers. The narrator feels obliged to point out that Kafuku did not hold other sexist opinions; this was something unusual he felt when a woman was behind the wheel. It's fairly obvious that this narration isn't really about driving, it's about Kafuku's distrust and aversion to intimacy, and it sets up his first meeting with Misaki Watari (who I will refer to in the book as Watari), the character in the film version hired to chauffeur him.

Writer/director Ryusuke Hamaguchi knows that the film adaptation cannot begin here. To do so would be to give the audience an unfair first impression of his protagonist, which is fine in a short story, but very difficult to overcome in a film. He needs the audience to understand Kafuku's loss before we can take him down the road toward healing. And so, in the film's first scene, he economically and powerfully sets the tone and introduces three critical narrative tracks.

In the opening frame, we see Oto Kafuku (the main character's wife, who I will call Oto throughout), framed in silhouette. It's a gorgeous shot, and one that plays up her mystery and spectral nature. This will be a ghost story about her, a connection the audience can subliminally expect in the shot without understanding why.

We then see that the couple is in bed, and she's telling a story. This expresses another important narrative. Storytelling will be an omnipresent force throughout this movie. Characters are always engaged in multiple stories in "Drive My Car" those that they tell or act out, those they slowly reveal, and those they live. There's also an immaculate homage here to Hamaguchi's mentor, Japanese director Kiyoshi Kurosawa, whose horror classic "Cure" also opens with a spouse telling a story.

But this story from Oto is erotic, and we hear it while the couple is undressed in bed, so we assume the conversation happens after sex. This is a third narrative track of "Drive My Car" — how sex both enhances and hinders intimacy. Sex plays a critical role early in "Drive My Car," but takes on less importance as the movie progresses.

The story Oto tells is a shared experience between them, and we later learn that it's a part of their erotic ritual. It's not her monologue, but one that she leads and allows Kafuku to add detail and clarity.

Their story takes up the first four minutes of screen time. It's not a single take, but Hamaguchi uses only a few different camera angles. Hamaguchi prefers to direct this way: with simple setups and long takes. He believes it allows actors to do their best work. He also shoots his films in sequence, so this was the very first scene shot as well. It's clear that the actors have rehearsed this scene extensively; their chemistry is evident.

We then get three quick shots of downstairs in their apartment, featuring the couch, Kafuku's desk, and their stereo system. This is a flash-forward in a sense — all three items will be prominent in an important upcoming scene. The movie then returns to the couple in bed in an overhead shot, where they seem to head into an afternoon slumber.

The movie's tone is beautifully set. We know that this couple shares a deep intimacy that's both erotic and intellectual. We next see them in the red Saab — with the driver on the left side — that will take us through the rest of the film. They are still talking through the story. We discover later in the film that Oto tells these postcoital stories as if in a trance, and that Kafuku must recall the details to her later, making it an essential part of her creative process.

He asks her if she wants to write it now, but Oto responds that she doesn't know the rest of the story yet, and never does from just one encounter. Kafuku says he thought it might be about her first love, but Oto laughs and rejects his theory, saying, "Of course it's not." You get the sense from their exchange that Kafuku wasn't her first love, but certainly her most important one.

Kafuku drops Oto off at the television studio where she works. There's a somewhat awkward goodbye between them — they talk about Kafuku's play that night (a performance of "Waiting for Godot" in which he stars) and he gives her a pass to miss it if her work schedule won't allow. She promises to be there. It felt a little formal to me, but given the warmth of the exchange right before it, maybe that's something uniquely Japanese.

From these opening scenes, the viewer would have no sense that anything is off in their relationship. But that good feeling won't last long.

# 2

# STORY CHOICES, CASTING CHOICES

One reason I admire this film so much is that, in adapting the Haruki Murakami story, Ryusuke Hamaguchi makes one bold decision after another, and they all pay off. He introduces many complex concepts that make it highly re-watchable. He understands the essential truth in Murakami's story and never loses sight of it, but knows the right supplemental influences to add depth along the way.

The next scene begins in a theater, a production of Samuel Beckett's "Waiting for Godot" that we discover isn't just an acting gig for Kafuku; it's his production. So we're watching a theatrical staging of a movie adaptation. We immediately notice that there is a superscript on the stage, displaying for the audience the text in both Japanese and English. I assume the spoken language in the scene is Japanese, but given how "Uncle Vanya" is staged later in the movie, perhaps I'm mistaken — and this would also explain the necessity of the superscript.

Why would Hamaguchi make this language-complexity part of his story? This is his invention; it's not part of the

three Murakami short stories used in the film, but it's a very interesting detail, turning Kafuku into someone with a unique vision of language complexity.

Although Beckett is Irish, a Paris production was staged first in French as "En attendant Godot," making the subtitles and the play's inclusion in this adaptation more interesting. And there's really nothing more for me to say about Beckett's classic that a million more qualified sources have written by now. The play is so deeply ingrained in pop culture that Sesame Street once aired a "Waiting for Elmo" satire.

I want to point out that the section of Godot chosen by Hamaguchi included an allusion to suicide, which is the first sign that Kafuku's state of mind is not quite blissful, despite the "happy wife, happy life" vibe left by the first scene. Something is clearly wrong in Kafuku's life. We can read it on actor Hidetoshi Nishijima's face even though we don't understand why.

That understanding comes quickly enough. We're now backstage and Kafuku is taking off his makeup. Oto arrives and tells him it was great. This seems to relieve him. But he's left no time to soak in the praise, because Oto immediately asks if he would like to meet someone new. Kafuku responds that he would, but would like to change out of his costume first. Oto is not listening to the last part, however, because she hears the yes and immediately introduces Takatsuki.

Here is one of Hamaguchi's most interesting casting choices. Instead of making the Takatsuki character eight years younger than him, as he was in Murakami's story, he makes him roughly half his age. This is the same casting decision made by Kiyoshi Kurosawa with "Cure" — he had originally written the part of Mamiya to be roughly the

same age as Takabe, but then cast an actor half the age of his protagonist. "Drive My Car" and "Cure" have some similar themes as well, although I'm not familiar enough with the Kurosawa film to explore them in too much depth.

On the surface, nothing of importance happens in this scene — at least that's how it seems on an initial viewing. Once you know what's coming, you notice a little more happening in this three-way encounter. The chemistry between Oto and Takatsuki is fascinating. Technically, I suppose, she outranks him, so some dominance would be expected, but she's doing everything but dragging him along on a leash here.

She chides him for referring to her as Kafuku's wife. Then she touches him on the arm when calling him the heroine's love interest in a new TV show. And towards the end of the conversation, Oto teases Takatsuki for saying the performance moved him, saying, "You're a strange young man." The way she smiles at him afterwards clarifies that the insult was affectionate.

It's also worth paying attention to Kafuku's words and personal engagement in this scene. His tone remains constant, and he avoids the others' gazes as much as possible. But he recognizes Takatsuki from some of his wife's shows and at one point says, "He always has a good role." I took this as Kafuku saying he's one of your favorites; it's obvious, so don't pretend he's someone new.

The scene ends with Oto and Takatsuki leaving, then Kafuku tossing the vest he was wearing onto a stool to his left. It feels a little exasperated to me. But we then cut to more clothing. Kafuku is packing a small suitcase, and judging by all the airline stickers still on it, this is something he does fairly frequently.

He tiptoes down the stairs to the apartment, not wanting

to wake Oto, who is sleeping on the couch below with her laptop. Besides his suitcase and jacket, he's carrying a blanket, so he thoughtfully tucked her in before heading out. The tucking in awakens her, however, and they kiss. Kafuku notes that he has a flight at Narita Airport, which is a 60-kilometer drive from central Tokyo, so he has to leave in a hurry.

He gets to the door, but turns around and sees Oto following him; she hands him cassette tapes. She has recorded all the parts from Uncle Vanya onto tapes, leaving space for him to rehearse his own lines in between. Personally, I can't imagine a more loving act than creating these tapes for your partner. And Kafuku will treasure these tapes for the rest of the film. They share another kiss, and now it is Oto's turn to remind him he's going to miss his flight if he doesn't break it off. He leaves the house and Oto walks back into the living room. The camera stays stationary; however, letting us see that the mirror in the foyer's hallway gives a very clear view of the couch.

We then see Kafuku put these tapes to immediate use, running his lines from Uncle Vanya. Throughout the movie, the text of Chekhov's play will serve as a commentary on Kafuku's unconscious. So even though he left his house in a state of bliss, the underlying tension is there in the Vanya lines. Perhaps he is thinking of his career in contrast to this new young star his partner is cultivating. Or perhaps he's thinking of how his marriage is not all as it appears as he recites:

Nobody knows how I feel. I cannot sleep at night from frustration and anger. I've wasted my time. I could have attained so much from life, but it's too late now at this age.

To add more sting to the lines, he's hearing Oto's voice in

response to this lament, and she tells him not to blame his past conviction for where he turned out in life:

But your convictions were not the ones at fault. You were the one at fault.

He then pulls into a parking lot at Narita and gets a message from the theater company in Kamchatka. Weather has delayed the event he is traveling for; they advise him to stay at a hotel near the airport and reimburse them later for the cost.

But Kafuku decides, fatefully, to drive home instead.

3

## THE REVEAL

I wrote in the last section that Hamaguchi made scores of adaptation decisions in bringing "Drive My Car" to the screen and never seemed to make a wrong choice. Today I'm going to ponder one big decision he made and question if, while not exactly getting it wrong, he might have gone too far.

As noted in the first essay, Hamaguchi began his film in a unique spot and with a different tone than Murakami did in the short story. In the original story, Murakami introduces Kafuku with a bias about women that he holds, opening him up to criticism right from the start.

In the movie, Hamaguchi makes the wise choice to build sympathy and understanding for his protagonist. But perhaps the director took it too far and made Kafuku into too saintly a character. What made me wonder if this might be the case was watching another Hamaguchi film, "Asako I & II" yesterday and noticing the parallels between Ryohei (one lead in that film) and Kafuku. In "Asako," it makes complete sense for Ryohei to seem too good to be true; he's a literal contrast to another character

named Baku, played by the same actor as his bad-boy equivalent.

I've heard Hamaguchi explain how the adaptation process for "Drive My Car" began while filming "Asako I & II" (he even used actors from that movie to workshop some scenes) and it makes sense to me he would view these characters as similar. But there's a somewhat sinister edge to the Kafuku in Murakami's "Drive My Car" that never appears in the film adaptation. Does the story miss the version of this character who lost his license because of drunk driving and who ideates destroying the life of a man who had an affair with his late wife?

Perhaps what the story loses in justifiable hurt and rage, it gains by exposing Kafuku's cowardice, something that's embarrassingly displayed in the next scene. But before I get to it (and yes, I am delaying a bit, because this is a painful section of the movie), I want to point out that Hamaguchi did not just draw on the story "Drive My Car" in this adaptation, he took from several stories in the "Men Without Women" short story collection. That story Oto began telling at the story's beginning? That comes straight from " Scheherazade."

And the scenario of this scene sort of comes from the story "Kino." In both scenes, a husband walks in on his wife having sex with another man. Except in "Kino," the husband picks up a bag of dirty laundry, leaves the house and never comes back.

Kafuku arrives home from his canceled fight and hears both Mozart's "Rondo in D Major, K. 485" as performed by Vadim Chaimovich playing on the stereo and the sound of heavy physical exertion coming from Oto. It doesn't sound like her having sex — she could be in the middle of some kind of very strenuous workout. But Kafuku treads

cautiously. We later discover, via Kafuku, that he's walked in on Oto having sex before. Now remember the placement of the mirror in the last scene — Kafuku can see clearly onto the couch without ever stepping foot into the living room.

When he gets within range of the mirror, he sees Oto riding on top of a man, straddled mid-couch, with his head to the back of us. Oto is facing the mirror, but has her eyes closed, her hands in the man's hair. She almost seems in a trance (which matches the description of the woman in the story "Scheherazade," who also needs sex to recall details from her stories) and has it compulsively as a creative act.

Kafuku watches for about 10 seconds, then quietly exits the apartment. I'm amazed he can watch even that long. While the scene is erotic, I've wanted to look away every time I've seen the film, not out of prudishness, but sadness over this scene's impact. There's no confrontation here, no evidence left that Kafuku witnessed anything. He goes to pick up his car and still looks remarkably calm. But he's unable to light the cigarette he's holding, which is the only evidence of how shaken up he is.

We next see him at an airport hotel — now taking advantage of the free hotel the event organizers had promised — and he lights a cigarette with ease, so he's apparently composed himself. He is at his computer, apparently waiting for a video call from Oto, which happens right away, but he allows it to ring several times before picking up.

The conversation is banal, composed. It makes you wonder just how often she engages in activities like this, but remains comfortable with the deception. Kafuku throws in his own deception this time — pretending that he is in Vladivostok. Why not — one airport hotel looks exactly like another. It's important to remember here that they are both

actors and are therefore highly skilled at regulating their emotions for a scene.

The action now skips ahead a week. Kafuku is driving back from the airport into Tokyo. He's working through his "Uncle Vanya" lines and recites this:

> For 25 years, he's pretended to be something he's not. Look at that swagger, acting like he's some kind of lord.
>
> Oto's voice: "You envy him, don't you?"
>
> Kafuku continues: "Yes, I do. I envy him a lot. Such good luck with women! Don Juan himself couldn't have had more experience. His first wife, who was my sister ..."

We hear a car horn blaring down and then see that Kafuku has smashed into a car that apparently had the right of way. We soon learn that Kafuku has issues with his peripheral vision that might have played a role. But given the lines he is rehearsing and the trauma he just lived through, it seems just as likely that his anguish distracted him.

# 4

# TOUCHES

Oto is next seen walking briskly through a medical center hallway, her back to us, once again a ghost, but this time a purposeful one. She turns to the right and sees Kafuku, they embrace. She says "what a relief," and he says he's ok. But then he adds that he doesn't really know if he's ok yet.

This is the first time he's seen Oto since the reveal. There's a heaviness to Kafuku that we haven't seen before. When he says that they've examined him but haven't revealed the result yet, I get a sense that he wants something to be wrong. He wants something to increase her guilt, make her need to stay closer.

The doctor tells them that he has glaucoma in one eye (he doesn't tell us which). Both Kafuku and Oto look so much older in this scene as they get the results. Kafuku asks if he can drive and the doctor says he can if it doesn't progress too much more — he prescribes drops to lower the pressure on the eye.

I find this diagnosis interesting because the condition is not bad enough to disqualify him from driving, making it

possible that it also had nothing to do with his accident. As mentioned previously, the novel offers a different reason for Kafuku needing to stop driving — a drunken driving incident that happens much later in the story's timeline. The way it's handled in the film is much more subtle and effective.

The doctor ends this scene by saying that you might doubt the effect of the drops, but you'll lose your vision if you don't use them. Oto at this point puts her hand on top of Kafuku. He lets it sit there, but does not embrace it back.

We cut to a beautiful shrine in the rain, and then a picture on an altar of a young girl who died February 25, 2001. We see them standing, side by side, in silent mourning for 25 seconds. This is their daughter, who died at the age of four. This also, by the way, places what we are seeing in these early scenes in 2010 or 2011, likely February 25 of either year. This scene is also likely a week or two after the one at the eye doctor.

The scene then cuts to Oto and Kafuku in the car. The red Saab has just been repaired and Oto is driving. Oto mentions that she knows he would rather be driving it now, which leads Kafuku to give his version of that bit that opened the short story: he says that he loves everything about Oto except for one thing. No, not her adultery, which they still haven't addressed — her driving. He tells her to face forward and then a few seconds later inquires why she didn't change lanes. She laughs and says this could qualify as verbal harassment.

Again, Kafuku is displayed in a much kinder light than in Murakami's story — there's no general sexism about women driving, just lighthearted banter about Oto's driving. They have just shared a painful experience, recalling the

death of their daughter, and are primed to discuss difficult topics.

So Oto asks if he ever thought about having another child and he dodges the question, in a way, saying that it wasn't something worthy of thinking about because Oto didn't want to have one. She apologizes, but he says that's unnecessary, that they made the choice together. The way Kafuku's relationships develop later in the film — especially with Watari — I think he's lying here. He feels a deep sense of loss about not having a child.

Oto says "I really do love you," and Kafuku thanks her. She adds "I'm so glad you're with me." The camera cuts to their hands. This time they are clasped. Whatever doubt and fear existed before has passed for Kafuku. But you can tell by his answer about kids that there's so much unexpressed between them.

The single most unexpressed emotion is his terror. He cannot imagine living without Oto, which means doing or saying anything that might ultimately lead to his marriage's demise.

## 5

## THE LAMPREY

What follows that very tender moment in the car is one of the great erotic sequences in film. It takes up about 7 minutes of screen time, but it speaks volumes about the marriage and the individuals both connecting to and confusing one another. It is certainly one of the most literate sex scenes ever filmed.

But I'm getting ahead of myself. This scene is in three essential parts. It starts with a lovely shot of a darkened room — the mirror dead center. You hear the couple's footsteps first, then a light comes on. You see them in the mirror. They pass in the living room, each turning on a light. We see Kafuku embrace Oto. His expression is lustful, hers mournful. They kiss, then he quickly begins to undress her.

She looks detached, if not quite disinterested. She seems to be going through the motions. We then cut to them unclothed on the couch. Only a few minutes of screen time ago, the couple looked tired and somewhat old in a doctor's office. But here, they look remarkably fit and vigorous. Kafuku is on top and Oto seems to be searching for a soft connection between them, but he then pulls her up into a

seated position, the same sexual position that he caught her performing earlier with Takatsuki.

We, of course, don't know this, but I get the sense that this is an unfamiliar sexual position for this couple. Oto now looks dissociated. The movie cuts to a shot of a lamp. We then see the couple lying together on the couch, Kafuku half-asleep, Oto awake and pondering.

After about 10 seconds of silence she says "One day she remembers her previous existence." Kafuku rouses and replies "you mean the girl who sneaks into houses?" And Oto says "She'd been a lamprey in her previous life." A word about the lamprey story — as I mentioned previously, this was not a complete invention of Hamaguchi. He adapted the lamprey tale from Murakami's short story "Scheherazade." But what he's done with it is something far more fascinating than the original.

In the story, the lamprey is a mysterious creature, one that sways with the currents and feeds on trout. But in Oto's tale, the lamprey is noble, but also acts compulsively, latching herself onto a rock as a way of not feeding on fish, perhaps embracing death.

Hearing this story from Oto first in a postcoital state, but then continuing onto a new sexual act, we begin to wonder — who or what is the rock Oto is grasping onto? Is it her sexual compulsions that she cannot give up? Or is it Kafuku and her safe, comfortable life? Or maybe it's her continued grief over her child's death?

You can see on his face that he's puzzling this out — what is her unconscious revealing? I almost wished in this moment for some of Stendhal's brilliant psychological narration of the conflict, but in truth, the silent mystery is so much more powerful and pays off later in the film.

Kafuku has his own fascinating reaction to what is

happening. His attempt to recreate Oto's sexual scenario did not lead to a similar passionate moment, but one far softer and sadder. But now, telling the lamprey story, her passion has returned. This is her story now, and apparently her libido needs that level of control.

But now it's Kafuku's turn to feel distant. Why can't he get this level of passion in the scenario he wants to act out? What happens from here is so brilliant that I feel inadequate to recount it. The girl who breaks into her crush's home in her story — the one who was a lamprey in a past life — is suddenly turned on thinking that she has become a lamprey again and she begins to masturbate on the boy's bed. But while doing this, she hears someone enter the house, and now she's certain that she is going to be discovered.

However, she can't stop and feels both arousal and a sense of relief that she will be caught in the act. Kafuku listens to this story, but also is taking part in a sex act where Oto is becoming deeply aroused as she talks.

As the story rises and her sexual activity peaks, Kafuku covers his eyes ... as if he's embarrassed to discover that maybe Oto has known all along that he walked in on her.

## 6

# THE REHEARSAL

I know what's coming and I'm not in a hurry to get there, much like Kafuku. But in between that devastating love scene and the abyss, there's this melancholy pause.

It begins with Kafuku at his desk and on his computer. He's on YouTube, watching videos about lampreys. He watches a lamprey affix to a fish, sucking the life out of it. He does this robotically, as if in a daze.

On the stereo system, Beethoven's String Quartet No. 3 in D Major is playing on the turntable. Except it's skipping (which, to be honest, is not so easy to notice with this recording) but Oto does pick up on it, so she walks in from an adjacent room and removes the needle from the record.

She then asks her husband if he remembered the story from the night before. As we'll discover later in the film, Oto never remembered her postcoital stories, which is why she relied on him (and likely others) to recount them.

He lies and says that he was asleep, so doesn't remember them. This leads Oto to respond that it probably wasn't worth remembering in that case. Kafuku then gets up from

## Kafuku's Ghost

the desk and says that he has a workshop to teach, which surprises Oto.

As he walks to the door, Oto hands him the keys, asks if he feels ok to drive (he says that he is fine) and then asks if it's ok for them to talk when he gets home. Kafuku says of course, why would you ask? They exchange pleasant goodbyes.

We find out later in the film that he actually had nothing to do that day, he just drove around aimlessly trying to avoid Oto's requested conversation. We see Kafuku driving and rehearsing his Uncle Vanya lines. All of the practice dialogue here is important.

>Oto's Voiceover: Is she faithful to him?
>Vanya/Kafuku: Yes, unfortunately
>Oto's Voiceover: Why "unfortunately"?
>Vanya/Kafuku: Because that woman's fidelity is a lie through and through.

This part of the car dialogue takes place during the day, the next part happens at night (so we know that he's been driving and rehearsing for hours.) The play (and perhaps upcoming discussion) rehearsal continues:

>Vanya/Kafuku: My life is lost. There's no turning back. That thought haunts me like an evil spirit day and night. My past went by without event. It's unimportant. But the present is worse. What should I do about my life and my love? What happened?
>Oto's Voiceover: When you speak to me of love and romance ... I feel like I'm in a daze and don't know what to say.

At this point Kafuku arrives at the parking garage for his apartment building. He seems in no hurry to get inside and have this conversation with Oto. The dialogue continues:

Oto's Voiceover: Oh ho, the Lord have mercy ... Kafuku: Sonya ... I'm miserable. If only you knew how miserable I am. Oto's Voiceover: What can we do? We must live our lives. Yes, we will live our lives, Uncle Vanya. We'll live them through the long, long days and the long, long nights.

Oto is reciting Sonya's monologue, the most famous speech of "Uncle Vanya" and one we will hear in different contexts throughout the film. While Kafuku will eventually see the hope and wisdom of the speech, right now he can only glimpse darkness.

Kafuku takes out his eye drops and puts some in his left eye. He's facing straight ahead in the car. We notice that part of the drops are on his cheek, running down like a tear. "Uncle Vanya" continues in voiceover:

Oto's Voiceover: We'll patiently endure the trials that fate sends our way. Even if we can't rest, we'll work for others ... both now and when we have grown old. And when our last hour comes, we'll go quietly. And in the great beyond, we'll say to Him ... that we suffered ... that we cried ... that life was hard ...

He now exits the car and goes up to his apartment, thinking he's about to have one of the most difficult conversations of his life.

## 7

## THAT LIFE WAS HARD

As Kafuku is riding up in the elevator to his apartment, those last lines from Chekhov are ringing in his ears. It's about thoughts during dying days and what one might say to an Almighty. These are lines about suffering, mourning and living a challenging life. Kafuku is thinking of himself at this moment and his own situation.

He walks into his apartment, again seeing first the mirror as he enters, and then the narrative shifts radically. Perhaps it's a time to be reminded that it's Oto's voice reading Chekhov and affecting him so much.

Now Kafuku sees Oto collapsed on the floor. He tries to rouse her, then checks to see if she's breathing. He's stunned for a few seconds, then calls the emergency number for an ambulance. The camera is poised above them. Kafuku remains remarkably calm as he makes the call.

In the short story, Oto dies of cancer. Even though the cancer comes on suddenly and progresses rapidly, Kafuku has some time to adjust. Here Oto dies in a flash from an aneurism.

The next shot we see is of the same shrine where Kafuku and Oto went to mourn their daughter on the anniversary of her death. There's a driving rainstorm. We see Kafuku's face first among the mourners. We don't recognize anyone among the first mourners we see in the background because the movie has been so tightly focused on the couple.

We have no idea what their social circle might be or what extended family they might have. But at the first cut, there is someone we recognize — Takatsuki. He's bowing down on the floor, then looks up towards Kafuku. He looks a combination of heartbroken and frightened.

It's a ballsy thing to do — to attend a funeral when the husband you've cuckolded is at the center of it. In the story, something similar happens, and the two men strike up a surprising friendship shortly after the funeral. It takes more time for the men to come together in the film.

Kafuku is greeting attendees as they leave. Two men bow with Kafuku, then as they walk off one says "So sudden ... a cerebral hemorrhage."

Then Takatsuki approaches. They bow at each other. Kafuku keeps his head down as Takatsuki raises his and then walks away. Kafuku's incapable of meeting his eyes. The camera stays on Kafuku after Takatsuki walks away. As he stares straight ahead, we hear Kafuku reciting Chekhov.

At first we don't know the source of the lines, as he says:

For 25 years he's been pretending to be someone he's not.

Then we see the back of Kafuku's head and realize that we are now in the stage performance of "Uncle Vanya." We're about to re-hear lines that Kafuku practiced in the car earlier, ones he used to express his rage at the Takatsuki affair.

His next lines:

Look at that swagger, acting like he's some kind of lord.

We now see another actor, who says:

You envy him, don't you?

Kafuku as Vanya responds:

Yes I do.

(He stands up and walks towards the back of the stage, the audience to his back ... which makes for a dramatic film shot, but would have been a major theatrical faux pas.)

I envy him a lot.

(He then turns towards the audience.)

His first wife, who was my sister ... was a wonderful, kind woman. And she loved him from the bottom of her heart, the way an untainted noble human loves an angel.

(Long pause ... Kafuku turns around, in part away from the audience, and towards the character he's speaking to)

And his second wife, as you can see, is a lovely, smart woman. Why?

The other actor asks:

Is she faithful to him?

Yes ... unfortunately.

Why unfortunately?

Because ... (pause) ... that woman's fidelity ... (long pause) ... Is a lie through and through.

Kafuku now walks off stage and we can see another character inquiring about him, calling out "Vanya?" Those unfamiliar with the play might think Kafuku has broken down and walked off the production. But this is part of Uncle Vanya.

This gives Kafuku a moment to compose himself during an extremely emotional moment in the play for him. The play continues without Vanya. We then fade to black and fade back in with Kafuku driving his red Saab.

The words "two years later" come onscreen. And now the audience, still in shock over the death of Oto, are greeted with a different kind of shock from the filmmakers. The opening credits. Yes, we have just sat through a 40 minute prologue, one of the longest in the history of film.

8

## THE STORY BEGINS

Actually, before we get the opening credits, we get a few more stray bits of information. The first is the title of Two Years Later. Two years later, Kafuku is still driving that red Saab. Perhaps more noteworthy — even though we assume the Uncle Vanya performance is in the past, he is still listening to his late partner's tapes as well. We get this narrative:

> Of course ... I'm sure ... that the truth, no matter what it is, isn't that frightening.

And then the film cuts to audio tape in a record, then the mouth of Oto, who recites:

> What's most frightening ... is not knowing it.

Oto, who started the movie as a spectral image, is now haunting Kafuku to the core. We see that he's just slept in his car and then wolfed down a doughnut. What exactly has happened to his life in these two years? We next see him

check his phone where he's plotting what looks like an extremely long car voyage to the Hiroshima Arts and Culture Theater.

He places his phone on a dashboard stand, takes a sip of coffee and begins. The titles come on. Kafuku drives through what looks like very pleasant weather, perhaps on an early fall day given the look of the trees. We get our first shots of Hiroshima, which look very lovely, somewhat similar to Vancouver to me, nothing like I remember the city from Resnais' masterpiece "Hiroshima Mon Amour" in the late 50s. Good to be reminded early that the Hiroshima of Resnais has no more resemblance to that modern city than the films of Ozu have to modern Tokyo.

He pulls into a garage in the arts center and is greeted there by the theater manager, Yuhara and the literary advisor for the project, Yoon-soo. They are new characters for this film, not a part of the Murakami universe in any way. We now get a bit of exposition. Yuhara explains that this is a two month residency that includes six weeks of rehearsals and two weeks of performance, running roughly from the beginning of November through the end of the year.

They then start leafing through call sheets — audition calls were made throughout Asia for the performance, which will be in several languages simultaneously. Apparently the project has drawn great interest and even attracted some well known performers.

They then explain that, as he asked, lodging has been found an hour away from Hiroshima, which will allow him to rehearse the play (or rather listen to Oto) on the way to work and back each day. Yuhara then lets him know that he will have a driver — and when Kafuku pushes back, explains that this is non-negotiable, a previous performer got into a serious accident in a previous production and this

is now required of the director as a condition of employment. As an aside, Yuhara has only a couple scenes in the movie, but I enjoyed her placid bluntness.

Yoon-soo says he is, of course, allowed to test the driver, although the driver is highly skilled. They then leave to meet the driver.

After the highly dramatic prologue, this first scene of the film proper is a bit of a breather. Given all that Kafuku has been through in the story, I don't think anyone minds taking all of the drama out of the chauffeur backstory. He doesn't need a DUI or some legal requirement to get the story on its way, it's better showing him a little kindness.

# 9

# DRIVING TEST

This long segment — nearly eight minutes total — introduces the audience to the most important relationship in "Drive My Car," that between Kafuku and his driver, Misaki Watari (who I will refer to from here on as Watari.) It begins with Kafuku's discomfort, perhaps because it's a woman who has been hired to chauffeur him.

Bordering on rudeness, Kafuku's first words to Watari are that he has not agreed to hiring her as his driver. He even questions letting her test drive him on the first trip to his island rental property, saying that the car is old and quirky. But Watari remains poised and says that if he notices anything dangerous about her driving, he can take the wheel at that time. Kafuku agrees.

The driving sequences are subtle, but display some clear acumen on Watari's part. This is interesting, because the actress playing Watari — the wonderful Toko Miura — didn't know how to drive at the time and had to learn before she was formally cast in the role.

She executes a precise three-point turnabout to exit the

parking lot, then maintains a steady 10-2 grip of the steering wheel, just as my driving instructor Coach Bunyard taught me in Driver's Ed class. She also gives ample advance warning to cars she's about to pass with her turn signals. Kafuku becomes comfortable with her driving and then asks her to put on Oto's cassette tape.

At this point, Kafuku carries on one of his most angry proxy arguments with his dead wife, via Vanya. It's Vanya's famously self-pitying "I could have been another Schopenhauer or Dostoyevski" speech (and hearing it again, I wonder if this inspired the "I coulda been a contender" speech from Brando in "On the Waterfront.")

By now it's clear that Kafuku would still much rather rehash that argument with Oto that never happened than interact with a real, live human being. The scene ends with him apologizing to Watari for their early 8 a.m. start the next day — the closest he is ready to get at this point to telling her she's earned the job.

## THE SPECTER OF OTO

Before getting back in the red Saab and moving the plot along farther, I want to spend some time on the character who will not return to the story, but remains a presence through her voice.

Oto's recording of "Uncle Vanya" for Kafuku was, on one level, an extremely thoughtful gift. Imagine how much time it must have taken for her to read all of these parts with the correct tone to assist his performance, leaving just the right space for his lines in between. I would be deeply touched if someone did something like that for me.

But on the first viewing of "Drive My Car," it's impossible to treat Oto with that level of compassion. We are naturally judgmental of the cheaters in relationships and eager to defend the transgressed upon. It takes time with this movie, beyond its three-hour run time, to appreciate Oto, even if we never fully understand her.

Every time I rewatch this movie now, however, I feel deep empathy for Oto. Her strangeness is quite beautiful. It doesn't hurt that she — as played by Reika Kirishima — is

physically attractive. But her beauty isn't just surface level, the character has unusual depth and ability to surprise us.

For me, two factors heavily mitigate the extramarital sex she engages in during the scenes we watch and (apparently quite frequently) off screen. One is that Oto remains in deep mourning over the loss of her daughter. There's something about the character that just seems dead inside, and I can only imagine how awful it must feel to lose a child.

The other mitigating factor is that sex for Oto is essential to her creative process. Sex is a literal and figurative creative act ... but for Oto, it creates a trance-like state where she imagines the stories that make her career possible. I don't know if any human has ever had this bizarre condition, but I can imagine that it would be the most addictive thing on earth for someone with a drive to create.

Finally, I also have to admit that I'm attracted to the mystery of her. And I suspect Kafuku is as well. So many of the later scenes in the film feel like suppressed arguments between the couple played out in the context of Chekhov's beautiful play. Mystery is infuriating in that way, especially for someone whose life is all about honest personal expression.

I think, also, that those who devote their lives to expression need a mysterious presence in their lives to balance what they do. To be expressive, you need to lack an emotional dimmer switch. You either choose to share – fully and honestly — or say nothing.

The mysterious are often the same way, they just err to the side of nothing most of the time. So the expressive envy them, and perhaps the mysterious are in turn drawn to the expressive because they wish to let it all out at times as well. They just, for whatever reason, can't let themselves be that

vulnerable. They have to retreat into actions that seem disconnected, with words left unsaid.

# 10

# CASTING

Having written about why I find Oto to be an appealing character, it's only right that I also explain why I have a strong affinity for Kafuku. His state of mourning makes him sympathetic, of course. Even though we are a couple years removed from Oto's death, I don't believe he ever stops wearing black in the film, unless he's in costume for a part.

But there's something else about his personality that hits a positive note for me — he's someone who measures his life by accomplishment. I have never been a person who finds joy in a static state of being, my greatest happiness comes from doing something I care about. Kafuku takes this approach to amazing extremes. It's not enough for him to stage a play as complicated as "Uncle Vanya," he has to do so in numerous languages simultaneously. That's a crazy level of difficulty, and I admire him for that.

So as we begin casting the play, the first thing we notice are the audition sheets he's leafing through. His first potential actress is from the Philippines and speaks Tagalog and English. The next is a man from Taiwan who speaks

Chinese (I assume Mandarin) and English. The third, an older woman, has an audition sheet in what I assume are Japanese characters.

And then Kafuku is stunned to discover an audition sheet from someone familiar — Takatsuki is trying out for the play. This guy hasn't an ounce of shame, of course, but let's keep the focus on Kafuku. The easy way out right now would be for him to just throw the sheet in the trash and not give it a second thought. But that would be very un-Kafuku.

After all, it's highly unlikely that Oto just became a complicated woman late in life. While neither the short story nor film go into this detail, I'm guessing that there was a layer of mystery to her right from the beginning and it was this complexity of character that drew Kafuku to her. He's not someone who wants to take an easy path, and he's also still deeply engaged in the project of figuring Oto out. No matter what he thinks of Takatsuki, Kafuku knows that he needs his insights to help unravel her mystery.

The next shot is of Watari removing a protective cover from the Saab as Kafuku observes her, walking on the sea wall. There seems to be admiration in his gaze, not about Watari or her features, but the professional way she is taking on this assignment.

We're now back in the Saab and again listening to Oto/Chekhov. The conversation this time is far more tender between them. Kafuku/Vanya notes that the look in her eyes is exactly like that of her dead mother's (perhaps another intermittence being noticed.) This leads Kafuku/Vanya to express sorrow for her mother's passing.

I'll leave the initial casting scenes for the next essay and will end with this — at least in the early stages of this project, I both admired and saw myself in much of Kafuku's behavior and his tastes. But as the project progressed, I

began to see others that I knew who mourned loved ones as being closer analogues to Kafuku than me.

Regardless, I completely understand why Kafuku loved Oto and continued to do so long after her passing. And I think he probably loved her for her faults just as much as her virtues, despite the torment those faults sometimes created for him.

# 11

# VANYA

"Everyone probably thinks you'll be playing the role."

Kafuku has a casting problem. He's pleased with the auditions, but there's a major hole — few auditioned for the lead ... and given that he recently played Vanya on stage in Tokyo, it's no great leap for anyone to assume that he will be playing him again.

There's another factor at work here as well. Kafuku is so identified with Vanya now, it's intimidating for another actor to take it on under his direction. Imagine trying out for Hamlet with Laurence Olivier directing the production. It would be terrifying.

Kafuku has been assuming all along that he wasn't going to take the role this time, but he also knows that he has this daily ritual of listening to Oto's tape and reading Vanya's lines. He's ready to step in at any moment. So he has to fight the instinct to just jump in.

By the way, I have to mention that I was wrong about Kafuku wearing black in every scene. He's in a navy blue suit with a grey sweater in this one. I stand corrected.

Kafuku leaves after a long day of work, Watari is waiting for him, reading on a bench. He apologizes, she offers no complaint. I love this about her — she never has a complaint. She knows her job and she does it professionally. Without saying a word, you know that Kafuku admires her for this.

I also want to point out here that we are now more than an hour into the film and the primary relationship of the story is still largely silent and awkward.

They drive home in that silence. We, of course, do not see the full ride home, so we don't know if the tape ever comes up during the drive, but its absence is telling. Kafuku is coming to terms with choosing someone else for his role.

Now it's the next morning and the cast is assembled in the office. Everyone in the room has passed their audition and will have a role in the play, but they are advised that they might be cast in different roles than they tried out for … it will be up to them to decide if they want to sign their contract and accept.

Yelena goes to Janice Chang, and she looks elated. (Have to say it again — I'm really looking forward to seeing Sonia Yuan in another film soon, she is lovely.) Sonya goes to Lee Yoo-na, and she looks unsurprised. We find out soon that her husband is actually Kafuku's assistant — a relationship he kept secret from Kafuku — so perhaps she already knew. Takatsuki looks shocked to hear that he has been assigned Vanya.

He mentions the age gap. Kafuku is unfazed and says he'll wear makeup … then adds that he is free to turn down the role. Janice Chang (ok, for some reason I like using both of her names and will keep doing so) then gives Takatsuki a big congratulations. It seems rather flirty, to be honest, so when Takatsuki then signs, perhaps he's prioritizing his

next sex partner. We'll soon find out, by the way, that Takatsuki has a highly compulsive sex drive.

I'll pick up tomorrow with the first script reading, and will end with this — it's not easy for Kafuku to pass on the role of Vanya, but he also understands the heavy emotional toll this role can take. He also must know that it's going to be a massive challenge for Takatsuki to pull this off. It almost feels like an act of sadism to make him try.

## 12

## KAFUKU'S DEPRESSION

If you want to know what high functioning depression looks like in a middle aged man, just observe Kafuku throughout much of this film. It isn't just that he's in mourning, he's staying afloat purely by sticking to routines and holding onto his obsessive need to better understand Oto. But that isn't apparent from appearances. He's in charge of this show and everyone around him interprets his blankness as self control and confidence. He appears to know what he's doing at all times. Few question him. Nobody asks if he's ok, even as he's showing compassion for others.

The composition of these first rehearsal scenes says so much about his state of mind. The wallpaper in the rehearsal room features prominent vertical lines, suggesting prison bars. Kafuku, to me, looks dejected throughout. Jumping into Chekhov again is not a joyous experience. He knows the text too well, feels the power of all the disappointment and longing in the script.

Kafuku does not explain why he demands actors speak slowly, enunciate and drain the emotion out of their deliv-

ery. The effect he is looking for is similar to the films of Robert Bresson, who director Hamaguchi admires. Bresson outlined his philosophy of acting in a book called "Notes on the Cinematograph." It includes lines like: Production of emotion (is) determined by a resistance to emotion. Be precise in the form, not always in the substance (if you can). Every movement reveals us (Montaigne). But it only reveals us if it is automatic (not commanded, not willed). Talking of automatism, this also from Montaigne: "We cannot command our hair to stand on end; nor our skin to startle for desire or fear. Our hands are often carried where we direct them not."

So, yes, by way of Robert Bresson, I have now connected "Drive My Car" to Montaigne, another personal obsession. Hamaguchi is also an admirer of John Cassavetes, whose over the top dramaturgy is the polar opposite of Bresson. But at least at this point in this film, he's following Bresson's lead. In an interview in Cineaste Magazine, Hamaguchi says he finds Bresson's attunement to voices especially inspiring: Bresson heard an immense amount of information in voices. They may appear very flat, especially the delivery of the models, to the point where some people say Bresson treated his models like dolls. Within those Bressonian models, however, there are lively variations in voice. As time passes, I become increasingly convinced that Bresson was attuned to those nuances. I want to have that kind of ear myself.

The acting restraint complements the physical restraint of the audition room. I think what Hamaguchi is doing at this point of the film is setting up the contrast between the work of theater and the freedom of the open road. Even in a communicative art like the theater, putting together a production requires restraint and professionalism. This

gives Kafuku an opportunity to hide, to burrow deeply into routine and deny his feelings.

Towards the end of rehearsal, Takatsuki and Janice Chang seem to be rebelling a bit against the restraints, putting more speed and emotion into their delivery. But before Kafuku can intervene, an alarm goes off signaling the end of the work day.

Kafuku walks out of the building and sees Watari sitting on a stone bench, reading. He asks if she's cold, and she replies "not at all." The drive begins and Kafuku asks (requests?) that she wait in the car for him and not sit out in the cold. Watari says no thank you — a rare moment of defiance for Kafuku, who has become so used to getting his way. She says that she knows how much he cherishes the car, so she wouldn't be able to relax. Kafuku replies "if you know that, then it's no problem. Just smoke outside." It might be a translation issue, but I'm not sure what he means. Watari then accepts the offer with a compromise — she'll wait in the car only when it's too cold to wait outside.

This kind of dance the two are engaging in, where both refuse gestures of kindness, is typical of depressed people. They are denying their own mental states by pretending all is fine. They seem to understand each other as they come to an agreement.

The ride continues and Watari asks if he wants to listen to the tape. Kafuku agrees. These lines from the play are heard from Oto's voice: But allow me, as an old man, to give one word of advice before parting. Everyone ... the important thing is to work. You must keep working.

What follows is a musical montage of the actors repeating the lines. We don't hear their voices. We only see Kafuku looking on, blankly.

## 13

## THE OPPRESSION

Having seen "Drive My Car" several times now, I take a lot out of this section of the film, but I can imagine how a first-time viewer might find it overwhelmingly sad at this point. Most movies about grief start from a place of happiness or at least contentment. But "Drive My Car" begins in an unusual place for a film about loss ... in a marriage with a great deal of love, but perhaps not much of a future.

Kafuku desperately wanted to hang on to Oto, but he knew that the relationship was making him miserable. You could hear it in his Chekhov recitals. He felt like he'd been dealt a losing hand in life, to love someone and have absolute focus on her, but to know that something was deeply wrong. The relationship so thoroughly consumed Kafuku that it made it impossible for him to form deep connections to others. This was not true for Oto, and that only made matters worse.

When she died, Kafuku was frozen in place and remained just as devoted to his late wife as he'd been when she was alive. He's sleepwalking through this section of the

## Kafuku's Ghost

film, hanging on to his routines and his modes of life without sharing with anyone why they need to be part of his ride.

But I know that this oppression will be lifted soon, so I have an advantage over first-time viewers of the film. I know that two of the most beautiful, rewarding scenes I've ever encountered are coming up shortly. But we're still not there, and we have to get through a little more awkward frustration first.

Watching the actors during the musical montage act without Kafuku's clear direction, I'm reminded of the similarity between the way he treats his actors and how Oto treated him. Kafuku demands that they accept an unusual style of performance, but never explains why.

We will hear him describe his method to Watari a few scenes from now, but he doesn't clue in the actors. Why? The movie never explains his motivations, but I do find the parallel curious. Maybe it is Kafuku who avoids clarifying communications — even in the case of accepting Oto's sexual transgressions. He would rather remain steeped in mystery and keep others frozen in that place.

We next get a tantalizing opportunity for Kafuku to open up — an invitation to drinks from Takatsuki. If you've read the short story, you know that the two in the story form an unusual but close relationship and find a way to relate and share experiences about Oto. And that's coming, at least in part, a bit later in the film, but it doesn't manifest in this scene.

They meet at Takatsuki's hotel bar. He starts by telling Kafuku that he would look him up online to see what he was doing, and that's how he came across this production and knew to try out for it. Kafuku asks why he's interested in him, and he responds that he liked acting out Oto's screen-

plays ... and when Kafuku says his production is nothing like those screenplays, Takatsuki declares that there are similarities, mostly involving an affection for details.

That points to an issue that seems to me to be highly Japan-centric and not immediately obvious to American viewers of this film. I've read some interviews with Hamaguchi where he has lamented that the younger generation of Japanese filmmakers has lost touch with the traditional Japanese film industry focus on the details of cinema.

If you watch classic Japanese cinema — something by Akira Kurosawa or Yasujiro Ozu — you're overwhelmed with what these masters pack into every frame of film. Every shot seems painted. You're meant to pay close attention to every artifact on the screen. So when Takatsuki talks about noticing something like this, he isn't really making a unique point about Kafuku and Oto, he's really just identifying them as being from that old school of Japanese story creation.

Then Takatsuki says that he's "working freelance these days," leading Kafuku to remark that he knew this and "didn't need to look you up to know that." This is the first time we're made aware of the public sex scandal that led to Takatsuki being fired (or perhaps even cancelled) off a major Japanese TV series. The ensuing conversation about it is very awkward. Kafuku chides Takatsuki for doing something so foolish. Takatsuki then tries to align himself, saying that women throw themselves at him — I'm sure it happens to you too. Kafuku responds "you only need to say no."

The conversation only becomes more awkward from here. First Takatsuki talks about how there are certain things about women you cannot know until you have sex with them, which seems to baffle Kafuku. There seems to be an enormous gulf between the characters at this point and

Takatsuki remarks how Oto must have been so happy to have a husband like him. I have to take an editorial break now to say — c'mon — really, Takatsuki? You fucked this guy's wife and have the gall to talk about how happy their marriage must have been? How does Kafuku keep his composure amid this? He responds "I wonder ..." And he doesn't look angry, just mournful.

But Takatsuki keeps pushing it. He asks if Kafuku could tell him something about her, such as how they met, or how she wrote her screenplays ... that second part really took balls, because Takatsuki knew very well that sex was an element in her screenplay creation and he's actually asking her late husband for more details about it.

I wanted Kafuku to punch him at this point, but instead he says here's what you're thinking ... here are two people sharing the same pain because we were both in love with the same woman ... Takatsuki dances around the issue for a bit, but admits that he was in love, in an unrequited fashion. He notes how lovely Oto was, creating a second of alignment between them, before he then destroys that unity by saying how jealous he is of Kafuku. Kafuku seems bemused and annoyed with the comment at the same time.

From here, the scene devolves into Takatsuki getting angry at a guy at the bar who took his picture which leads to an angry confrontation with that man. This elicits a rebuke from Kafuku, and the scene dissolves from there. I must admit that I'm not really a fan of the violent-with-paparazzi subplot introduced in this scene and punctuated later. I think it's not well developed and a rare weak point of the film.

Kafuku leaves, and Takatsuki catches up with him as he's getting in the car, offering an apology and another awkward moment, saying that he believes Oto brought them

together, and he's looking forward to continuing their collaboration. So while this scene does not give us that moment of connection we're eager for Kafuku to have, it does give him an opportunity to flash (even in a highly reserved manner) some real human emotion. He clearly hates this guy. He's probably regretting putting him in his play. But he still, oddly, wants him around.

    I have no idea why.

## 14

## THE REVOLT

We reach the final pitch black scene in "Drive My Car" before some light shines in. And in a sense, like the last sequence, there is some glimmer of daybreak here because emotions are getting a little raw.

It begins in the car, Oto asking:

What's the matter? You look so glum. Is it because you feel sorry for that professor?

But we don't hear Kafuku respond, even though the camera remains on his face for a few seconds more. What follows is a scene that a The New Yorker piece highlighted as a good example of how the film makes strong use of the literary source material throughout.

We hear Takatsuki's voice respond:

Leave me alone.

And then we get the "on the nose" next line of the play from the character Astrov in Uncle Vanya:

Or because you are in love with his wife?

Takatsuki/Vanya responds, earning a side eye glance from Kafuku even though he's delivered the lines probably a thousand times by now:

She's a good friend of mine.

Astrov answers:

Already?

Takatsuki/Vanya:

What do you mean by already?

Astrov:

There's a proper order for a woman to become a man's friend. First she's an acquaintance, then she's a lover, and finally, she becomes a good friend.

At this point Kafuku is completely annoyed with Takatsuki for mouthing the lines he's cast him to deliver, and so he starts picking on his delivery and saying his scene partner is doing it right, emulate him. After correcting him again, Janice Chang has finally had enough and comes to Takatsuki's defense:

Janice: We're not robots.

Kafuku: What do you mean?

Janice: Of course we will follow all of your instructions. But we're not robots, and I think we'll do better if we know what your intent is.

Kafuku: You don't have to do better. Just simply read the text.

Hamaguchi is smart to have Janice Chang lead the rebellion. She both has a crush on Takatsuki and is extremely likable. Kafuku is being a dick. Yes, sure, they don't have to do better. But they are still owed an explanation about your intent, Kafuku.

The scene soon ends, Kafuku thanks everyone for their hard work. A few actors hang behind and joke about the odd process of rehearsals and how boring it is to just read lines. Meanwhile, deep in the frame, Janice Chang and Takatsuki are attempting to flirt without knowing a common language.

Yoon-soo has found an excuse to get Kafuku out of the office and will soon ask him for a ride — and will ask him to come by his house so he can apologize for something. What follows is a scene of pure joy, the turning point of the film.

## 15

## THE DINNER

This scene never fails to bring tears to my eyes. So much is going on, text and subtext.

It begins in the car. For the first time, we have three people in the Saab, Yoon joining Kafuku in the back seat. Yoon is such an appealing character throughout, but until this scene, he didn't carry much depth. He's talking about the languages that he speaks — Korean, Japanese, English and Korean sign language. He explains that Korean and Japanese have similar grammar, so it's just learning vocabulary. And English, he says, appealed to him since childhood.

But why sign language, Kafuku asks? Yoon deflects: I have an apology to make to you. I hope you can join me for dinner, where all will be explained. Kafuku clearly doesn't want to do this. He's not interested in this point at making deeper connections, he's being friendly to Yoon because it makes his work easier. But he feels obliged — and he shares this obligation with Watari, who is even more grudging in her acceptance of the dinner obligation.

We arrive at the house, greeted by Yoo-na and a dog ...

and we now find out that Yoo-na is actually Yoon's wife, which is the reason for the apology. Kafuku hears this news and lets out a small sigh. This could be interpreted in many ways, but in my most recent viewing, Yoo-na reminded me somewhat of Oto, leading me to wonder if Kafuku had a crush on her. As the scene plays out, it's obvious that he's very charmed by her, but I'll just leave this as a theory for now.

If Kafuku wasn't already a bit in love with Yoo-na, he almost certainly was after the dinner. She was a dancer and she had a miscarriage recently (an alignment with Kafuku's past.) She wanted to perform again, but says that her body wouldn't let her dance, so at Yoon's suggestion, she decided to audition for the play.

The story is charming (as is Yoon's description of his love at first sight and need to learn sign language to get closer to her.) But it's the way Yoo-na challenges Kafuku that really binds them. He asks her if anything about the rehearsals is challenging, and she responds "why don't you ask that of any of the other actors? You don't need to be nicer to me than the others." But she says it with a look of warmth and empathy, not reproach.

And Kafuku immediately appreciates the criticism. She then goes on to explain that while she is used to people not understanding her words, she sees and hears things in rehearsal that others might miss, and that's what is important about it. Kafuku appreciates this. She then really wins him over by saying that Chekhov's text comes inside her and moves her body that was stuck before. This sets up the beautiful climax scene of the film, where her performance of Sonya's monologue feels a bit like a dance.

At this point, Yoo-na tries to connect with Watari, asking her if she likes the food. She gets a thumbs up, but it still

feels distant, like she doesn't feel like she belongs in the conversation. Yoon picks up on this (he and Yoo-na really are an extraordinary couple) and asks Kafuku how he likes her driving.

Kafuku takes a beat and says "it's fabulous." He then goes on to give highly specific praise of her driving habits, saying that he often feels like he's not in a car at all. He punctuates it by saying "I've experienced many people's driving, but it's never been so pleasant."

The way Toko Miura responds throughout this speech as Watari is priceless. She's staring straight ahead ... her chewing seems to slow down the more the compliments sink in with her. By the end she's clearly in a state of shocked bliss.

And then something happens that is just magical, one of my favorite moments in any film. It's a personal bias. I admit to being such a hopeless dog dad that I have great affection for anyone my grumpy puggle Bogey likes. So maybe that's playing in the background for me.

Watari spots Yoon and Yoo-na's dog on the floor, she goes over and starts playing affectionately with it. This is a human being who, in this moment, can only fully express her joy by becoming canine. I don't need or wish to say anything more about this scene. (Except to note Yoo-na's wonderful jab that maybe Kafuku should be as kind to the actors.)

Up to the moment when Watari got down on the floor, it was a wonderful, empathetic, expressive scene. But when Watari started jostling with the dog, it became something special. And the movie was transformed in a moment.

16

## THE FRIENDSHIP

The last scene makes possible this, the first glimmer of friendship between our dual protagonists. I don't feel like my last essay fully captured the weight of the dinner scene, but there's so much to unpack in it that I have to give myself a pass. Like Wenders in "Perfect Days," Hamaguchi is attempting in this film to square Eastern and Western philosophies, and this is massive challenge for these filmmakers that could swallow me up as well.

I will not attempt to finish the project both have begun, but I feel obliged to bring up a core issue that Hamaguchi and Wenders are addressing. Uninformed Western critics of Zen Buddhism see within it a retreat into self absorption. Indeed, any philosophical approach that centers on personal enlightenment risks entering that space, but the Western misconception of philosophical tenets like detachment, nothingness and, for lack of a better word, mindfulness, end up highlighting weaknesses in the Western approach rather than accurately describing the Eastern.

In both films, we are confronted with the question of

creating meaningful human connections amid personal philosophical journeys. American films typically resolve these kinds of conflicts firmly in favor of romantic relationships. The solitary hero learns that he needs not just others, but another, and a pair bond creates the climactic happy ending. In both "Drive My Car" and "Perfect Days," the requirement of a romantic match is hinted at, but not directly consummated. Instead, our existentialist heroes are permitted to create human connections by simply forming them with people who need them as well.

In "Drive My Car," that connection is explored through the unique and beautiful friendship of Kafuku and Watari, which officially begins in this scene. It crosses so many typical cultural barriers — a man and a woman, a significant age gap, a class divide, the employer/employee hierarchy. On top of all this, there's the cinematic cliche inherent throughout — if a man and a woman make a connection in a film, the audience is meant to assume that a romantic pairing is inevitable.

But it's a relationship that works because of fundamental alignments. Each is carrying enormous weight. There is grief on both sides, and an inability to easily articulate their pain. They need each other to bring these deep feelings to light.

Kafuku and Watari don't quite reach full-on friendship in this scene because Kafuku holds back from saying anything meaningful, starting with the news that Oto is not just his wife, she is dead and he is haunted by her. He tells Watari that Oto is the woman on the tape and that she is his wife, but stops there, letting the conversation flow into a discussion of his acting and directing method. But I need to back up at this point, because there's important material here even before the scene gets heavy and personal.

It starts with a long silence in the car, followed by Watari thanking Kafuku for inviting her. He points out that it was Yoon who invited her. She calls them a lovely couple, leading Kafuku to grunt positively. (It's really impossible for men to hide their feelings, and Nishijima injects the perfect amount of feeling into Kafuku here — he clearly has a crush on Yoo-na and is jealous of Yoon.)

Watari says she's now curious about rehearsals, especially Yoo-na as Sonya, and Kafuku invites her to watch, leading Watari to quickly back off, apologize, and ask if he wants to hear the tape. Kafuku answers affirmatively, but only listens for a few seconds before beginning a new conversation over it, asking if she's ever bored by the tape. Not at all, Watari says, she likes the voice on tape, leading to Kafuku's minimal response that the voice actress is Oto, his wife.

Why is Kafuku reluctant to say more? I believe that, especially in light of being in the company of the lovely couple that evening, Kafuku is ashamed of his grief. This is another thing about middle aged men that might be hard for younger generations to understand — even if we're able to be vulnerable and discuss our feelings, we tend to judge ourselves harshly for them. We may have surpassed the previous generations' need to always seem tough, but we can't stop ourselves from feeling that the expressions demonstrate our weakness, especially the longer feelings linger.

There's a mirror element to the scene, because Kafuku reiterates his appreciation for Watari's driving, and in this moment she could have given a shorthand version of the story, saying her mother taught her, without elaboration. Then perhaps the scene could have carried on with a discussion of driving methods. But Watari, for whatever

reason, now feels that she can trust Kafuku, so she tells much more.

She reveals that her mother taught her at a young age — while she was still in junior high school — to drive, so that she could be taken to the train station and perform far away from home in a nightclub. She had to learn not to wake her mother during these drives, otherwise she would get scolded and abused, so she took her driving seriously from a young age.

The story has a point — complimenting her driving means a lot to Watari for this reason. But it also shows her to have hidden reservoirs of courage previously hidden from us. It's the beginning of a wonderful friendship that transforms them both. But it's important at this point to make clear that Watari began that journey.

## 17

## THE FLOW OF THE PLAY

In the critical car scene I just discussed, Kafuku finally explains why he directs his actors the way he does:

The flow of the entire play has to be memorized with my method.

This makes sense — you can't have multiple languages overlapping in a performance and get any kind of performance out of your actors unless they have a deep understanding of the text. This leads to some frustrating moments for actors and might turn them into the kinds of "models" Robert Bresson used in his films and that I discussed earlier.

But Kafuku would argue that the text of "Uncle Vanya" needs no adornment, just clear recitation. So the scene begins with a long musical montage that blends rehearsal text work with Kafuku back in his rental house, working through the flow of the play line by line. The scene ends with the first shot in awhile of Kafuku using the eye drops.

We then return to a morning trip to the rehearsal hall, Kafuku once again listening to Oto's narration:

Will you tell me the whole truth afterwards?

We get a long pause here, likely waiting for a Vanya line, but Kafuku remains silent, deep in thought. Oto's narration continues:

Yes, of course, I'm sure that the truth, no matter what it is ... isn't that frightening.

And here Kafuku looks to his left and sees Janice Chang and Takatsuki driving in together. Since the two do not speak a common language, the obvious assumption is that they hooked up the night before.
The two young actors notice Kafuku and seem embarrassed, but drive on ahead.

What's most frightening is not knowing it.

Next the car takes a turn, and we hear the line:

Oh to flirt with a man like that and get lost in his arms ...

And then we see Janice Chang and Takatsuki at the side of the road after getting into an accident (Takatsuki being behind the wheel and likely responsible.) It has to gnaw on Kafuku at this point that he's the one being required to use a driver, but his star is getting into a traffic accident that has the police involved.

I guess I'm a bit in love with him too ...

Of course, Kafuku has a look of resigned disappointment as they drive by ... it's bad enough that Oto had to have

an affair, but why did it have to be with this dumbass? And why did he compound his own stupidity by putting him in his play? Just to stick the knife in a bit more, we hear Oto saying:

Yes, I miss him when he doesn't come ...

The scene continues next with the rehearsal, Janice Chang and Takatsuki arriving late, but I'm going to save the remainder for my next piece, because it better fits with the flow of what comes next.

## 18

## BREAKTHROUGHS

Up until this scene, it's really hard to tell if Kafuku actually is a good director. He gave his actors no clear directions and chided them for taking chances in their roles. But something has clearly changed for him — he's starting to use some of his social skills to pass on what he needs from his players.

Janice Chang and Takatsuki arrive at the rehearsal quite late — whatever went on at that accident scene apparently dragged on for some time. They apologize and Kafuku explains that their characters are in nearly every scene of the play, so they kept repeating the few scenes without them and even went off book to start physically performing some of them.

He then asks Janice Chang and Takatsuki to act out a scene. It's clear from the start that Takatsuki has none of the raw energy he brought to the rehearsal. He's defeated and whiny in this take and Janice Chang is having a difficult time reacting to him.

This leads Kafuku to call cut and declare that the scene

was terrible. Janice Chang agrees and notes that it has become clear to her that she needs to understand the full play, including everyone's dialogue, if she hopes to act with more energy. Kafuku, having made his point through the voice of Janice Chang, then turns everyone back to reading dialogue in the book.

They start reading the script, but Takatsuki has clearly been stung by the criticism. He catches Kafuku in the lobby after rehearsal and apologizes again, saying that he was just "lending her an ear" to which Kafuku replies "you say that, but you don't speak English or Mandarin."

Kafuku has clearly had enough of Takatsuki's lies by this point. He hired him for a reason — to get some clarity on Oto that no one else could provide — but he can't even get this guy to admit to what happened with his wife. And now he's lying about sleeping with another actress in the production (and probably someone Kafuku has a crush on.) He asks Takatsuki to use good judgment and he walks off. Kafuku looks dejected with him.

He asks Watari to find a place to drive, some place in Hiroshima that she enjoys. She takes him to a garbage incinerator, which gives us some interesting visuals of cranes picking up massive clumps of trash to be dropped in the fire.

Watari thinks the garbage looks like snow. She then takes him down an outdoor corridor which she tells him connects to the Hiroshima Peace Park, built in commemoration of the atomic bomb destruction. This for me sets off memories of the film "Hiroshima Mon Amour," with its tour of late 1950s Hiroshima — I'm pretty sure this locale was used, but before the incinerator was built.

Kafuku asks why she came to Hiroshima, and this provides another opportunity for Watari to open up,

explaining that her mother died five years ago in a landslide, so she decided to take the car and keep driving south and west. She ended up in Hiroshima, where she found work as a garbage truck driver.

She remains because the name Watari is common in the area and she believes her father lives nearby, although she's never met him. They discuss names a little more — Kafuku talks about what his name means and that Oto was reluctant to marry him because Oto Kafuku means "house of the Gospel."

This is a very interestingly blocked scene, with Watari sitting on a stair and Kafuku at the bottom — it gives the impression of him being onstage. Perhaps it's that familiar position that entices him to open up for the first time, saying that Oto died two years ago from a cerebral hemorrhage.

Kafuku asks if the tape now creeps her out, and Watari replies no, saying "in fact ..." but she doesn't finish the sentence. Instead she retrieves a frisbee from a dog owner and throws it back for the dog.

This is the second time in the film that Watari uses communications with a dog to help allay difficult emotions. She then shifts to saying how much she likes Kafuku's Saab, because she can tell it has been handled with care, making her want to handle it with care as well. She then says "let's go" and walks off.

To me, it's so interesting how Watari continually demonstrates her difficulty handling strong emotions, yet is the one who is always driving the emotional conversations. Kafuku, who has made a career plumbing emotional depths, is slower to reveal himself and, when he does, it's apologetic in form.

This scene makes clear that Kafuku and Watari have

formed a powerful and unique bond. It's the willingness to mutually share that creates lasting bonds between people, and it's becoming increasingly clear in the film how lucky the two are to have found each other.

## WATARI'S JOY

I'm not ready to move on from that last scene yet. Watari's inability to articulate her joy was wonderful to behold. She groped for poetic equivalents to her feelings — talking about how Kafuku's car and the care taken in its preservation makes her happy to drive it. And then she saw a stray frisbee and played with a dog, just like she had done earlier at the dinner.

For Watari, a young woman who has lived without a father, coming into contact with Kafuku is a revelation. She admires him, his praise means a great deal to her. But his vulnerability means even more. She hasn't experienced this kind of sharing in her life. We'll later find that the only person who ever shared kindness was her schizophrenic mother's alter ego, who was childlike in nature and far more open to Watari than her mother ever could be.

As someone who never has difficulty articulating, I find such difficulty appealing in a way. It comes so easy for me to express my thoughts and feelings that sometimes I begin to distrust my own words. I wish at times that it didn't come so easily, that there could be more struggle attached to my

expressions. Maybe then I would trust and embrace them more readily. Likewise, in some ways I trust people who can't find the words to explain their feelings and have to resort to gestures and signs that they hope are interpreted well.

Watari's gleefulness at Kafuku's revelation took a few viewings for me to catch. It's subtle and veiled, maybe hinting that Watari exists on the autism spectrum. My younger brother is autistic, and the way he expresses affection is to send me down an exhaustive list of movies that we went to see together in a particular year. David will say something like "Hey Dan, name all of the movies of 1983." The movies themselves aren't what he's recalling, rather he's showing nostalgia for a time when we went to the movies together a lot. He's saying that those are some of his fondest memories in life.

It can be incredibly laborious to go through one of David's thought exercises and I sometimes try to change the subject to a more recent movie (I really don't like 1980s nostalgia, but I tolerate it for him.)

We all have different ways of expressing to one another how much they mean to us. Being attuned to how others express joy is something that David taught me early in life, and I'm eternally grateful for his lesson.

## 19

## CLASS OUTSIDE

It was one of those running jokes in school growing up that whenever there was a very nice day outside, someone had to ask "can we have class outside?" After the heavy disclosures in the last scene — and the bad vibes Kafuku was carrying around from his encounters with Takatsuki — it's a great relief to see Kafuku turn away from another sad Vanya monologue in the car and notice the pleasant weather.

The next thing we see is the cast heading outdoors for rehearsal that day. And if that isn't joyous enough, Watari is there waiting for them. The scene that follows, featuring Janice Chang and Yoo-na, is important, because it shows the limitation of text in conveying what's essential between people.

This is something I've been thinking about recently, especially in the context of what Marcel Proust theorized about consciousness, that it's something embodied in our senses and nervous system, not confined to our heads. We can see Proust's theory in action in this scene. The words

between the characters are sharp and at times confrontational. But it's in the inflections, the touches, and the looks that their connection is apparent.

It highlights the central sadness of this post-pandemic age, that we think virtual connections are good enough, that we can send text messages and capture everything necessary between people — see and hear each other on Zoom and get all we need. But then I come into contact with people I connect with every day, face to face, and it's a completely different experience. The subtleties come alive. The things I might dissect when looking at mere words are understood much more clearly in the full physical context.

The implications for embodied consciousness are huge, in my opinion, because they rescue us from so many easy conclusions about human behavior. If we make many of our choices based on our feelings and senses, with the brain often coming in after the fact to provide a rational gloss, we can see how pointless it is to get lost in our heads and stuck in puzzles. We're acting in the way our bodies tell us is right, not necessarily because we're stuck in thinking errors. The answer to our greatest conundrums isn't working out problems in our heads, but listening to our bodies and fully understanding what's motivating us.

Next up is a scene with Takatsuki and Chang and, surprisingly, we don't get to see it. We can only assume by this editorial decision that the challenges with Takatsuki continue here. Kafuku arrives at the car later and remarks to Watari that it's cold. She agrees. She then thanks Kafuku "for the day." Kafuku asks for what, and she replies "nothing." It's the kind of miscommunication common between parents and children — a child is trying hard to connect, but at the first awkward moment, pulls away.

Before that awkwardness can play out, Takatsuki knocks on the window and asks if they can meet again for drinks. I'm going to stop here, because what follows is one of the movie's most important scenes that I need to pick up from the top.

## 20

## YIELDING TO THE TEXT

I want to jump ahead to a moment in the bar talk between Kafuku and Takatsuki. In explaining why he's not acting the lead in the play, Kafuku says "Chekhov is terrifying." When you say his lines, it drags out the real you. Don't you feel it? I can't bear that anymore ... which means I can no longer yield myself up to this role.

Kafuku's despair is fully exposed here. Up to this point, we had seen Kafuku as a curious but reserved soul, one who wanted to experiment with his art, and who more than anything wanted to reach an understanding about Oto.

No question he was in mourning, but until this moment, we had not thought of him as defeated, as someone who had seen enough of his true self and couldn't bear the sight of it anymore. But remember that during the previous scene, Kafuku already had a breakthrough, even if he doesn't recognize it yet.

He has found someone who he feels comfortable sharing with, so he doesn't have to make sense of everything via Uncle Vanya. So even though there is an unmistakable

air of defeat in Kafuku this scene, he's moving in a new direction already, he just can't feel it.

The scene is more about Takatsuki than Kafuku. He finds his director in the parking lot and asks for another drink meetup. He wants to know desperately why Kafuku chose him for a role he feels so ill suited for. Kafuku gives an honest, revealing answer about why he's not acting, but he's doing it to set up some powerful advice. One of the parts of this scene I like the best is the way Kafuku tries to reach his young star — by taking the vulnerable parts of his personality and showing how they can be a strength on stage.

You can't control yourself very well. From a social standpoint that's not good ... but not necessarily a drawback for an actor.

He's noticed qualities in Takatsuki that show potential:

You can yield yourself to your castmate. Do the same to the text.

Kafuku mentions auditions and rehearsals as the places where he's noticed these qualities, but I don't believe that — I think it's Takatsuki's seductiveness that Kafuku admires. If he can bring the same obsessive energy to Vanya, Kafuku sees an interesting version of the character to bring to stage. He's basically telling him that he allows himself to be provoked by women who attract him — now let Chekhov provoke you.

In the next shot, we see a photographer provoking Takatsuki by snapping a picture at the bar. Kafuku holds him back and brings their conversation to a close. Then we get an extremely important, but in my opinion, poorly staged scene that seals Takatsuki's fate.

Takatsuki meets up with Watari in the parking lot. She

says that she'll go pay for the parking. At that moment, someone else takes a picture of Takatsuki with his iPhone. We have no idea if this is the same person from the bar. But Takatsuki, with no one around this time to stop him, stalks the young man as he appears to enter a building.

What happens offscreen is important. We will later be told that during this 30 second segment, Takatsuki struck the photographer and put him in the hospital with wounds that eventually led to his death. In other words, he killed this kid in a bloodless fight that few enough people witnessed for him to leave without pursuit. (We later discover he was captured on video.)

What kind of anime superhero is this guy? Chekhov is famous for the line that if you see a gun in the first act, it will go off in the third. The filmmakers missed an opportunity here — they should have set up Takatsuki earlier in the film as someone with deadly martial arts skills. Takatsuki returns and he has no blood on him, no sore knuckles. No sign of throwing stars or nunchaku. He's just a guy sorry to be late, ready to hop back in the Saab. We assume he'd done something to the iPhone guy — probably smashed the phone, maybe some nonlethal battery.

I don't mind the surprise that the staging of this scene set up, but having seen the movie several times now, this segment doesn't hold up and it bothers me. But I doubt that there are too many people who've even thought about it.

# WHY KAFUKU CAN'T YIELD

The death of Oto in Murakami's original short story was a plot device, and it is in the film as well. Murakami has told many similar stories where the woman in question doesn't die, she just leaves. Often mysteriously.

And when thinking about Kafuku's emotions, I think we'll find that what is bothering him most is the same feeling he would have if, instead of finding Oto dead on the floor, he had come home to nothing, that Oto had left without notice.

The primary, crushing emotion that Kafuku is feeling is rejection. The woman he loved could not be faithful to him and ultimately left without explanation. Her death adds a level of guilt — he could have come home sooner and been there to call a doctor — and finality — we know that she took mysteries to the grave.

But those extra details just help the audience focus on the plot the way Murakami wanted them to — this time out, he didn't want us to believe that there was a mystery that would eventually be revealed. He wanted to make it clear

that the mystery would not be solved, even though Kafuku was intellectually committed to do so.

If Kafuku were still fully invested in that quest, perhaps he would want another round of Chekhov to explore it. But by now he feels conquered by Oto's mysteries. He's left with the feeling that he played a grand, elaborate game for her but in the end lost, and so now she's gone.

So how do rejected people feel? I think the first thing you'll notice that every rejected person has just taken a very strong hit to their self esteem, so they will look to restore that self esteem in whatever manner they feel most comfortable. For some men that might mean hitting the gym or getting better at guitar. For a man like Kafuku, it's staging "Uncle Vanya" in seven different languages simultaneously. In Hiroshima, not Tokyo.

The second thing about rejected people is that they become far more sensitive to criticism. Kafuku responds to people who challenge him by just shutting them out, sticking to his ideas and ignoring his collaborators. Many people act far more hurt and lash out at their perceived critics, so Kafuku is more mature on an interpersonal, cultural basis, but the outcome is at least as bad.

The third feature of a rejected person is emotional neediness. They are starving for attention and affection and will reach out, desperately at times, for reassurance and connection. Now this may seem completely unlike Kafuku, but look closer. This is a guy who didn't reject or lash out at Takatsuki, he hired him as Vanya. Even the hurt of seeing him isn't as bad as the lack of companionship.

And, of course, there's also Watari. I doubt that Kafuku in a different stage of his life would ever open up to someone in her position. He's too much in his head and feelings all the time to notice this silent, competent person

serving him. But he has to reach out and engage now, there's too much for him to relate.

The character arc of Kafuku is all about him testing the defense mechanisms he's deployed to protect him and help him recover. So we see both the promise and limits of Kafuku's artistic ambition. In the end, it feels like a definitive positive that he staged Vanya this way, but perhaps for different reasons than he anticipated.

He also becomes more open to adaptation and collaboration as the story unfolds. He sees over time that what others offer are gifts to the collective work, not challenges to his vision.

As for the neediness, Kafuku attains his ultimate breakthrough by embracing it. The next scene is all about that.

## 21

## LETTING IT ALL OUT

We arrive at the hardest scene in the film to write about. Kafuku starts letting it out and just can't stop once he begins. I don't know why he suddenly feels comfortable enough to talk so openly. Maybe being around Watari makes it possible. Maybe he's had enough to drink and is relaxed.

It's also possible that Takatsuki is finally vulnerable enough with him to make him feel like sharing. Takatsuki begins the scene by saying that he feels empty inside. That there's nothing for Chekhov's text to bring out. The only time he felt a text touch him that way was Oto's screenplays. He says that perhaps it is right that Oto brought them together.

If I were Kafuku in this position, I'd really just want to punch the guy. But given that he just murdered someone in the previous scene (not even in 30 seconds as I theorized in the earlier essay, I put a stopwatch on it, it was only 20 seconds), maybe it's best that Kafuku remains detached.

But he begins to talk about Oto. He starts by mentioning

their daughter, who would be 23 (Watari's age — and there's a glance between them to cement this connection.) He says that his daughter's death marked the end of their happy times. Oto quit acting and Kafuku quit working in television, returning to theater work. Oto was lethargic for years.

She seems to have been brought back to life through stories that came to her after sex. She would share and he'd remember them ... her writing would happen after the recall. This created a connection between them that hadn't existed before and the sex, Kafuku says, was also very satisfying to him.

But she had sex with other men, Kafuku adds (noting here that it is fine to say this in front of Watari.) He then puts Takatsuki in his place by noting Oto's pattern — she would sleep with men cast in her productions and would end the affair after the play was over. He needs to make it clear to Takatsuki that there was nothing special about him, he was just one in a series, just part of her method.

Takatsuki asks if he has any evidence of this, and Kafuku noted that he witnessed it, that Oto sometimes brought the men back to their home. Given that this is exactly what happened with Takatsuki, he now knows that Kafuku was always aware of their affair, so he can drop the pretense.

Kafuku says he never doubted Oto's love for him, she was just able to move effortlessly between him and these other men. And then he adds this remarkable description of her:

> Still, she contained within her a spot I couldn't look into where something dark swirled.

One of the interesting questions left unresolved in the

## Kafuku's Ghost

film is whether this dark place within Oto really existed. Takatsuki offers his opinion that Oto desperately wanted to talk to Kafuku clearly about her life, but didn't know how. Watari, in a later scene, suggests that there was no mystery to Oto, she did what she did without contradiction and still loved Kafuku throughout. Despite these theories being tossed around, Kafuku never fully embraces them.

Takatsuki edges into his monologue by inquiring of Kafuku whether he ever asked Oto about it. Kafuku says no, that what he feared most was losing her and confronting her felt like a sure way to lose her forever.

This is not at all an irrational thought for Kafuku. Women are conditioned at a young age to fear the strong emotions of men, knowing that those reactions, especially angry ones, can put them at physical risk. So it's not uncommon for women to avoid the kind of emotional confrontations that might touch off emotional reactions from men.

But in this case, Takatsuki has reason to believe that Oto might have wanted her husband to open up about her secret. And he reveals this by telling the end of the lamprey story to Kafuku, something Oto told him after sex, but not her husband. The intruder that Yamaga met in the house turned out to be a burglar, who tried to rape her, but Yamaga not only fought him off, she killed him by stabbing a pen in his temple (a very lucky hit — perhaps a foreshadow of Takatsuki's killing.)

She then is shocked to discover that the boy at school doesn't seem at all fazed by her presence, that this dead body at home doesn't seem to have shaken the equilibrium. She goes back to the house and notices a security camera installed (and no key available anymore.) Not able to take

the mystery unexposed, she looks into the security camera and says repeatedly "I killed him."

Takatsuki felt Oto had given him something important through this story. What's coming next is startling, and so I needed to return to Murakami's short story to refresh myself with the original language and to prepare for Takatsuki's speech. I want to quote from the short story now even though I think the film version of the speech is very powerful. Murakami's original is a bit more subtle and drawn out:

> "From what I can gather," Takatsuki said after a long silence, "your wife was a wonderful woman. I am convinced of that even as I realize my knowledge of her is no more than a hundredth of yours. If nothing else, you should feel grateful for having been able to spend twenty years of your life with such a person. But the proposition that we can look into another person's heart with perfect clarity strikes me as a fool's game. I don't care how well we think we should understand them, or how much we love them. All it can do is cause us pain. Examining your own heart, however, is another matter. I think it's possible to see what's in there if you work hard enough at it. So in the end maybe that's the challenge: to look inside your own heart as perceptively and seriously as you can, and to make peace with what you find there. If we hope to truly see another person, we have to start by looking within ourselves."

It's a very interesting turning of the tables. Kafuku has been the one with the sage advice and Chekhov in his corner on questions of the heart — now his young, out of control, semi-nemesis has cut him to the core. Kafuku is silent the remainder of the ride and they drop off Takatsuki

at his hotel. But there's a lovely final touch as he lets him out of the car — Kafuku gets back in the car in the front passenger seat for the first time. We may think that the speech had drawn Takatsuki and Kafuku closer together ... but it's actually his relationship with Watari that continued to evolve.

## 22

## THE SHARED SILENCE

Before we get to the plot twist, we get this lovely return car trip home, with Kafuku saying little more than a grunt. Watari doesn't say all that much either, but it all conveys a great deal of understanding and warmth between them.

Here's Watari's complete dialogue:

It didn't sound like he was lying. I don't know if it's the truth, but he was telling you what was true to him. I can tell. Because I grew up among liars.

There's greater depth to this scene than meets the eye. Kafuku is a man who likes to turn words around in his head to explore deeper meanings, and by now Watari can see this. So before he could begin processing Takatsuki's monologue this way — and perhaps interpret it as a sly evasion — Watari wants to validate it as having a ring of truth.

And she also aligns herself with Kafuku by showing sympathy for his situation, because she too lived with liars.

Kafuku doesn't respond verbally. Instead he hands her a cigarette and grants his approval for her to smoke. The scene ends with the lovely image of their hands together outside of the moonroof of the Saab, smoke streaming into the Hiroshima night.

## THE PLOT TWIST

The big plot twist of "Drive My Car" is coming up and I want to take a moment to laud how well it was set up. There are two key elements of the twist — Takatsuki's place in the story and Kafuku's mindset.

The scene that just passed fulfilled Takatsuki's purpose in the story. We were waiting for him to finally drop the act and give his own perspective of Oto, to stop pretending that he didn't have an affair with her. He finally tells everything he has to say and, in a bit of a surprise, even has some personal wisdom for Kafuku. So the story no longer needs him. If he stays in the film at this point, he risks becoming someone with his own story arc and we already have two characters to follow at this point. The story doesn't need him and they find a way out.

Kafuku, on the other hand, just fulfilled an important part of his journey, but had a new one set up for him. He finally admitted that he just can't face himself anymore and therefore cannot play Vanya in the production. But in coming to a new understanding of Oto, he also now has to

consider Takatsuki's words — that self knowledge and understanding of his own heart is all that really matters.

He's plumbed Chekhov's depths for a long time, but maybe he needs to do so one more time after coming to an understanding of his loss. Maybe then he can stare into the abyss of himself, instead of as a victim of Oto's mysteries. Perhaps then he can find something new in Vanya and himself.

For a man, it is very difficult to separate work from the personal. There's an element of work that is purely transactional, but there's also something that's more akin to spirituality — the part that's about living a purpose driven life, fulfilling a mission. My feelings for people always plays a huge role in the work I do. So I understand Kafuku's reluctance to take on that extra vulnerability.

The movie is ultimately not about solving mysteries or even coming to terms with grief. It's about embracing vulnerability in all forms and building a community of people with a shared mission to support you through it.

## 23

## THE ARREST

For a very long movie with a 40 minute prelude/overture and a somewhat relaxed pace at times, the last hour of "Drive My Car" is a nonstop cascade of important, dramatic moments. Hamaguchi signals a dramatic break in his film at the transition from the smoky car ride to the plot twisting stage rehearsal with a shot of a Hiroshima highway cloverleaf at night, creating a very striking X, and the sound of a stage gunshot intruding.

The cast is onstage for the final scene of Uncle Vanya Act III. Hamaguchi does a sly piece of editing with the text, moving the line about the "vulgar geese" in "Uncle Vanya" to after the shot going off, instead of before as Chekhov wrote it. It takes a bit of the sting out of the scene, making the audience think that the first shot fired was about Vanya scaring geese instead of attacking Serebrayakov. It simplifies a highly chaotic moment in the play, which is necessary, given the complexity of everything that's about to happen.

Kafuku interrupts to note (in English) that Vanya can't throw the gun away now, because that would change Act IV. But he still compliments Takatsuki for the performance,

which is far more impassioned than anything we've seen from him to this point. In the moment we are thinking that maybe the talk between the two men had an impact on Takatsuki. But what we will soon discover is that the depth of his own depravity has already caught up with him and he's fully experiencing feelings very similar to Vanya in the moment.

What quickly follows is probably the most polite manslaughter arrest scene in movie history. A highly mannered man from the Hiroshima police department named Kato — dressed in a suit, not in uniform — asks Kafuku to take the mic from his rehearsal desk, then asks Takatsuki if they may speak somewhere. He tells him that it is fine for him to say what he must in front of everyone. He knows what's coming. Kato says:

> On Sunday November 24 at around 7:30 pm, you got into a fight and beat up a man in Shintenchi Park. Is that correct? (pause) You were caught on camera. That man died in the hospital yesterday.

Takatsuki responds:

> Yes, I saw the news. I did it. That's correct.

Kato asks him to come to the police station. Takatsuki asks if he can change out of his stage costume first, and the police officer agrees. On the way out, Takatsuki (who had just put all of the cast and crew through this ordeal instead of turning himself in earlier) stands on the same theater row as Kafuku and bows deeply at him, then sighs and walks off with the police officers behind him. Everyone in the cast and crew is frozen in place, in stunned silence.

The scene now cuts to the Hiroshima North Police station. Kafuku and Watari are standing beside the Saab, waiting for Yoon-soo and Yuhara to report back on Takatsuki. Yuhara does all the talking:

> The lawyer says that Mr. Takatsuki admits to the charge of injury resulting in death.

Kafuku asks if he can see him, she replies not at this time. But she has an agenda she needs to get to:

> More importantly, what shall we do about the play?

Kafuku is stunned that she is so bluntly insisting on talking about this so soon, but she's insistent that they decide as soon as possible whether to cancel the play or have him step into the role. At first Kafuku sticks to his earlier stance and declares that he can't do it. Yoon-soo reminds him that he knows the lines and can perform in Japanese, so it is the best way to avoid any disruption in the play. He still says no, but when Yuhara says bluntly that this means canceling — and disappointing everyone who has been part of the production — he hesitates to give a final answer.

Kafuku asks for more time and is given two days. And I've watched this movie so many times but never picked up this detail before. Kafuku asks Watari if she knows a place where he can think in peace. She takes a step towards the Saab and knocks on it, saying nonverbally that the road is the best place for him to think and she'll be glad to give him as much time as necessary on it. They then work out the longest road trip possible to take in Japan and still make it back in time for the producer's deadline.

# FATHER FIGURE

Now that the Takatsuki story line is complete, this is an apt moment to examine the strange relationship between Kafuku and his rival, and how their pairing — as well as Kafuku's dynamic with Watari — play into his healing journey.

There is very powerful Oedipal dynamic going on between Kafuku and Takatsuki. While Kafuku recognizes the young actor initially as a sexual rival for his late wife Oto, he can't help but be aware of the generational difference and the fact that this young man could very well be roughly the age of a son, if Oto's pregnancy had led to the birth of one.

This takes us back to Sophocles and the Oedipus myth, where father and son are pitted off in rivalry for the affection of the mother. Oto's sexual infidelity was all about divided affections, perhaps her way of dealing with the loss of a child and the way she could share more connections in her life without another child. The generational difference set off something that for Kafuku, over time, developed into a father-son dynamic more so than a pairing of sexual rivals

— a major departure from the Murakami short story, where the two men were closer in age.

So Kafuku keeps giving Takatsuki surprising chances to grow and redeem himself. He didn't need to give him an audition at all, he could have just tossed the application in the trash, but he invited him in. Once that happened, he went beyond giving Takatsuki the part he auditioned for — he cast him in the lead. He keeps teaching and pushing the young actor throughout, trying to coax Takatsuki not only to give a better performance, but to grow as a person.

It's a deeply empathetic relationship for Kafuku, even if it's doomed to failure. Ultimately, Takatsuki's inner demons are too powerful. His impulsiveness cannot be tamed and a young man loses his life because of it.

I want to stop here to take stock of the fact that, with a major section of the film approaching that deals with questions of guilt and responsibility, the movie zips rapidly over this plot point, but could have easily been drawn into a question of Kafuku's indirect responsibility for the death of this young man. His monomaniacal (nearly Ahab-like) quest to understand Oto had a deadly, unexpected impact. While he didn't know the depths of Takatsuki's impulsiveness and rage, it's fair to ask why he let this live wire anywhere near his production. This is a weakness in the story line, and I believe the entire plot point of the Takatsuki manslaughter is poorly developed. But I'll leave it at that.

Kafuku both succeeds and fails with Takatsuki. He succeeds in turning him into a better actor and someone capable of being honest about his past relationship with Oto. But he fails to channel his dark nature in a socially-productive way, and then self-destructs. In the end, it feels like a worthy experiment that Kafuku attempted, even if the consequences were tragic.

What comes next in the film is the other familial relationship that Kafuku cultivates with Watari. This is a far more successful, beautiful connection. Perhaps the fact that Watari stands in as a perfect analogy for his lost daughter helps. What I find very interesting here, though, is the way the film subverts how movies typically address how men adjust and adapt to the loss of a romantic partner.

Movies of this type are almost always about the process of men learning to love again. And in a sense, so too is "Drive My Car." But what we find out in the course of the film is that while Kafuku remains obsessed with Oto, the most healing thing for him to do is create a family-like bond, perhaps indicating his own wound about losing the opportunity to be a father. When Oto is finally gone from his life, he does not gravitate towards finding another woman, he seeks out the children he never had. And that gives the final act of the film its emotional weight.

## 24

# THE DRIVE

In case you're curious what kind of drive Kafuku and Watari have ahead of them, I checked out Google maps and discovered that the filmmakers were not giving themselves any wriggle room in this voyage — it's a 26 hour drive across nearly the entire length of Japan, along its west coast, from Hiroshima to Kami-junataki village, including a significant ferry ride.

I assume Watari would be pushing the speed limits at times to make her promise of getting there and back by the 48 hour deadline they were given. (Although I suppose it's possible that Kafuku phoned in his answer somewhere along the voyage.)

What comes next is a very lengthy segment of the film with very little dialogue, just views of Japan from the highway, nothing terribly picturesque either. Kafuku suggests they split up the driving time to make it in 24 hours, but Watari refuses, saying that driving is her job and she can go a day without sleeping. (Here's another filmmaker sleight of hand ... they can only arrive at the village in 24 hours, it's actually a full two day journey there and back.)

They stop at a store called Komeri. According to their website, this is a store similar to a Home Depot in the U.S., making it an odd choice for a road trip stock up. Kafuku offers to let Watari rest at this point, but she says that she can sleep a little on the ferry.

They've been on the road quite awhile before Kafuku finally talks. He says:

> The day Oto died ... she asked before she left if we could talk when I got home. Her tone was gentle but determined. I had no plans that day, but kept on driving. I couldn't go home. I thought that once I went home, we would never be the same again. I found her collapsed when I returned late at night. I called an ambulance, but she never regained consciousness. What if I'd gone home a bit earlier? I think so every day.

We'd been waiting a long time for Kafuku to tell the whole story and to reveal his survivor guilt. But before we can process it, Watari jumps in with her own stunning monologue:

> I ... killed my mother. When the landslide crushed our home, I was inside, too. I was able to crawl out from the fallen house. After escaping, I gazed at the half-collapsed house for a while. Then some more debris came falling and completely destroyed it. My mother was found dead under the debris. I knew she was still in the house. I don't know why I didn't call for help, or why I didn't save her. I hated her, but that wasn't the only thing I felt about her. This scar on my cheek is from that accident. I was told surgery could make it less conspicuous, but I don't feel like erasing it.

And then we get this amazing moment of emotional leveling from Kafuku:

If I were your father, I'd hold you round the shoulders and say, "it's not your fault." "You did nothing wrong." But I can't say that. You killed your mother, and I killed my wife.

To which Watari just replies "yes."

They drive along some more, and enter a tunnel at one point. As they exit the tunnel, the night skies open up and a downpour begins. Hamaguchi loves filming rain scenes, there's a stunning one in his previous film "Asako 1 & 2" that I'd like to revisit at some point. This one cuts to the ferry ride, which is one more scene of silence between the two. I never noticed this before, but there's one shot where Kafuku is on the outside of the ferry, carrying some blankets, and he looks over the side of the ferry at the sea. And just seeing it again, I wonder if he contemplated jumping.

As Kafuku arrives in an empty room with Watari asleep on the floor, a TV can be heard in the background broadcasting the news of Takatsuki's arrest and the altercation that led to his victim's death. We also get details about the scandal that marred Takatsuki's career earlier — it involved a relationship with a minor the year before. Quite an odd romantic life this guy had — he went from an affair with a woman 20 years older than him to a fling with a minor? Did he have any limits?

When we see the pair back on the road again (Kafuku asleep in the car) we can see snow on the landscape, indicating that they've nearly arrived at their destination. We see them stop at a flower stand. And then they turn left onto a hilly, snow-filled side road and reach their destination.

They only seemed to speak for about a minute and a

half in a full day's journey, but the conversation they had was more meaningful than anything else they'd said to each other. I like the way Watari made no statement about Kafuku's story, she just related her own story with similar feelings. And then Kafuku both indicated his wish to show fatherly love towards her, but refused to fully embrace it and decided instead to sit in the sadness and guilt with her.

## 25

## SACHI

Watari and Kafuku park the Saab and walk up a snowy hill. At first Watari is disoriented and isn't sure where her old house might be. But finally she spots it — a distinctive blue/green roof standing out from a pile of rubble.

One at a time, Watari begins to toss flowers in the direction of the house. She says:

My mother had a separate personality called Sachi. She first appeared when I was 14. She said she was eight years old, but she never aged in four years. Sachi would often appear after my mother had beaten me terribly. It was like her awareness didn't match the body of an adult, so she couldn't stand well. She'd try to but fall over, and would end up just sitting still. Sachi liked puzzle rings. We liked to do crosswords together. Sachi cried for no apparent reason. Whenever she did, I'd hold her and rub her back over and over. I liked those times.

At this point Watari takes what's left of the flowers and tosses them all towards the house. The camera now faces her. She takes out a cigarette and lights up, then continues:

The last beautiful thing in my mother was condensed in Sachi. Sachi was my only friend.

Watari now walks down towards the house. She digs a hole in the snow and places the lit cigarette.

I don't know if my mother was mentally ill or if she was acting to keep me closer to her. But even if she were acting it was from the bottom of her heart. Becoming Sachi was my mother's way of surviving in a hellish reality, I think.

She looks back up at Kafuku and says:

When the landslide occurred, I knew that my mother's death meant Sachi would die too. Even so ... I didn't move.

Watari climbs back up the hill. Kafuku reached down for her hand. She says it's dirty, but he takes it anyway.
Now they are back at the top of the hill in a medium shot. The Sachi story was Watari's mother's equivalent to Oto's sexualized screenplays.
She now tries to connect them and asks Kafuku if he could accept everything about Oto as genuine, lacking in mystery, that maybe she loved him dearly and sought other men constantly, and there was no contradiction in it. She says Oto's behavior doesn't sound deceptive to her. She concludes by asking if that's strange and then apologizes for her opinion.

Kafuku looks at her intently without words, shifts his focus away from her, then gives his most inarticulate speech of the film, but one where the failure of words means nothing, it's his emotional surrender that counts:

> I should have been hurt properly. I let something genuine slip by. I was so deeply hurt. To the point of distraction. But, because of that, I pretended not to notice it. I didn't listen to myself. So I lost Oto. Forever. Now I see. I want to see Oto. If I do, I want to yell at her. Berate her. For lying to me all the time. I want to apologize for not listening. For not being strong. I want her back. I want her to live. I want to talk to her just once more. I want to see her, but it's too late. There's no turning back. There's nothing I can do.

At this point, Watari moves in to hug Kafuku and he embraces her tightly. Two people with deep survivor guilt have now revealed all. So where can Kafuku go in this moment of surrender and loss? To the only place he can, to the text of Uncle Vanya. And so he begins to paraphrase thoughts from Sonya's closing monologue:

> Those who survive keep thinking about the dead in one way or another, that will continue. You and I must keep living like that.

He now pulls her away and looks Watari in the eyes:

> We must keep on living.

He embraces her once more and says "it will be ok, I'm sure, we'll be ok." His fatherly love for her has finally won

out. We then get a long shot of the village where Watari grew up — and it looks quite lovely — then a shot of the Saab sitting alone in the snow. We won't see the two characters together in the car again in the film, even though they have an equally long car ride back to Hiroshima.

## 26

# ACTING

Watari is dropping wisdom all over the place in that last scene. It's an interesting role reversal — Kafuku loses his ability at the end to articulate anything about Oto beyond the passion she brings out in him. It's contradictory and staccato, but also completely genuine. I too sometimes feel something similar when I'm frustrated with someone I love, I'd rather pick a fight and have that person angry at me than not thinking about me at all.

On the other hand, Watari has a much clearer picture of her mother and insightfully notes that she never knew if her mother was mentally ill and splitting off into her alter ego, or if she was acting it all as a way of apology and attempt to keep Watari close. In a movie filled with actors playing actors, it's interesting to consider just when everyone is putting on a show and when they are being genuine — or if they can even tell the difference after awhile.

I do love that Watari was able to conjure up her simple, direct form of storytelling by the end of the film and, despite her reserved personality, say the words that sum up the film

the best. As I mentioned in a previous chapter, I find people like Watari more trustworthy in their expressions because their emotional articulation does not come easily. The fact that she is the only major character in the film who isn't an actor (or a theater brat) makes it more powerful.

That thought is central to the final scene of the film as well, where the emotional climax of "Uncle Vanya" — Sonya's monologue — is delivered in Korean sign language ... but more importantly is delivered in a fully embodied, completely loving fashion.

## 27

## SONYA'S MONOLOGUE

The movie cuts to a sunrise over Hiroshima. It's a beautiful palette that matches the previous scene, filled with shades of blue and orange. And before we can think to ask what comes next, we hear Kafuku's voice as Vanya:

I refuse! Wait, I'm not done yet!

And then we enter Vanya's great self-pitying scene from Act III:

You destroyed my life. I've never lived. Because of you, I wasted the best years of my life and spoiled them. You're my foe. My bitter enemy!

But then we witness the pure brilliance of Kafuku's production in a mad cacophony of language ... Japanese to Tagalog, back to Japanese to Mandarin. All fitting seamlessly. Do they hear and understand one another? Well, perhaps it's fair to ask if Chekhov's characters heard and

understood one another in the original Russian. My favorite moment is when the Professor says in Tagalog:

> What earthly right have you to use such language to me?

Chekhov understood the disconnect in words, the ways we use language to divide one another (or, harkening Nietzsche, how in all talk there's at least a grain of contempt) ... even when everything is spoken clearly and easy to understand, misunderstanding and divisive discourse is rampant. Vanya demands to be heard above all of the discord, asserting:

> I'm gifted and intelligent. Courageous, too. If I'd lived normally, I might have been another Schopenhauer or Dostoyevski. I'm sick of this nonsense! I'm losing my mind. Mother, I can't take it anymore!

It's in this moment that Vanya decides to shoot the professor. Kafuku stalks offstage, and just as in the earlier scene in the film when he played Vanya, Kafuku hyperventilates at a table and seems on the verge of a collapse. But there's a beautiful contrast between the earlier near-breakdown and this one. Early in the film, Kafuku faces his demons alone.

No one looks on or reaches out. This time, however, one by one castmates and crew look on with care and concern. We see now just how Kafuku has grown throughout the film. He may still be fighting his demons, but he's no longer doing so alone. He's created a circle of care around him.

The movie then creates some distance for Kafuku and enters the dressing room. Cast members sit watching the production on a monitor as it continues towards the Act IV

conclusion. We see them calmly watching, making and drinking tea, and showing care for one another. Janice Chang gets the last shot in the dressing room, watching the monitor intently as we move towards Sonya's moment.

We then return to the stage. I've seen numerous productions of Uncle Vanya and it is typical for Vanya to set up the monologue in complete breakdown and despair. But Kafuku chooses a more interesting approach ... he's smiling as he says "I'm miserable." His final line of the film is delivered with his head turned away from us as he says "if only you knew how miserable I am."

Sonya's monologue is one of the most famous pieces in theater, a showcase for actresses. I doubt if it was ever performed in Korean sign language before. It starts in a long shot so that the moviegoing audience can see how it was staged — with all of the play's languages displayed at once in superscript on screens.

We then get a shot of the audience, just long enough to see Watari. She stands out by wearing a light blue jacket amid a sea of olive greens and greys. Sonya is wearing a bluish-green shirt in the scene as well, creating a psychic connection between them. And it's glorious to see her perform her expressive words from behind Vanya, the gestures rising up beside him like a dance, her face over his left shoulder.

Touch is so important to the performance. She lays her hands on his shoulders, then touches his head. It feels like second person pantomime or even a silent film performance. The gestures of the language are beautiful, at times poetic. It's also performed with such beautiful pacing, never rushing, always making sure the meaning is conveyed even to those who don't know it.

And unlike most performances of Vanya, where the tears

remain on his face through the speech, Kafuku takes on a sense of wonder towards the end. He is enraptured by her vision of redemption and hope. The play ends with Sonya embracing Vanya — and then a close up of Watari, Kafuku's transformed soul daughter. They fade out with Sonya's arms around Kafuku, he calmly sighing. The last shot is of a dim lantern in a dark room.

## 28

## THE EPILOGUE

I'll be honest, I don't understand exactly what's going on in the epilogue. Maybe the easiest answer about it is that there's nothing really to understand. It's a simple scene of Watari shopping for groceries — most likely during the pandemic, because everyone is wearing a mask — but even that's not for sure, people in Asia seem to be wearing masks regularly even post-pandemic.

How many people is she shopping for? Hard to say. She has one basket of groceries, they all fit in her carry bag just fine. She could be visiting, because she doesn't want to save her purchase points. But maybe Watari just doesn't care about such things.

What's clear is that the scene takes place in Korea. And then when Watari leaves the store and enters the parking lot, we see one Hyundai after another, either white, black or grey. The only car that isn't is a red Saab, which is the vehicle Watari enters.

There's a dog inside. Is it the same dog from earlier in the film? Maybe? They were a Korean couple. Maybe they've returned home after the production and Watari has joined

them. But how did she get the Saab? Is Kafuku living there as well? Maybe. Or perhaps he just gave her the car because she loved it so much.

Watari starts the car and drives off. While driving, she removes her mask. Earlier she noted that she could have had a facial scar removed, but she kept it to remind her of her mother and the loss. But now the scar is gone. The scene takes in a dreamlike plane — is this Watari's form of heaven? Is this her idea of what life would be like if she could stop toiling and just rested?

She sees the dog come towards her. She gently tugs the hair under his mouth. Then the camera views her from the front and for the first time in the film, we see a glint of smile on Watari's face.

She's driving the Saab with a dog as a passenger. How can life get better?

# ABOUT THE AUTHOR

Dan Conley is a Chicago-based speechwriter, ghostwriter and author. He has served as the chief speechwriter for Virginia Governor L. Douglas Wilder, Chicago Mayor Richard M. Daley as well as leaders at numerous non-profits. He has written the Movies Scene by Scene series, that includes analysis of "In the Mood for Love," "Yi Yi" and "Aftersun." His book "Essai by Essay" chronicles a 13 year daily journey through Michel de Montaigne's essays.

# ALSO BY DAN CONLEY

Essai By Essai

Things We Can't See

The Love Story that Never Arrives